# BARRON'S ART HANDBOOKS

# VEGETATION

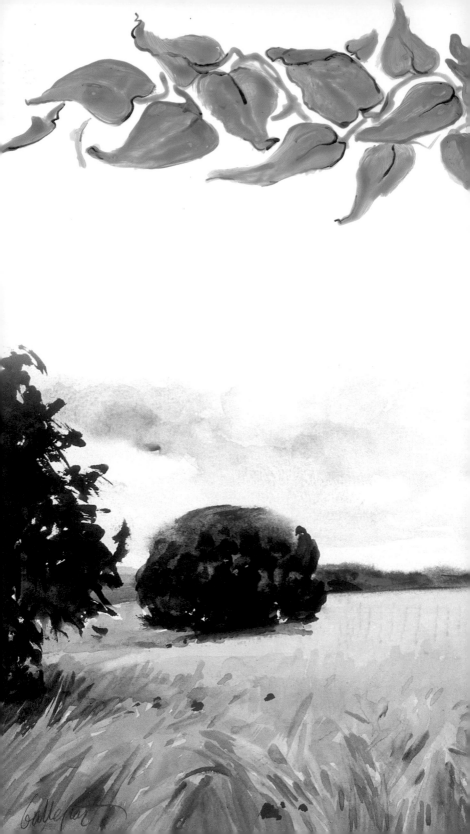

# BARRON'S ART HANDBOOKS

# VEGETATION

# CONTENTS

# VEGETATION IN THEMES

Still lifes and rural landscapes generally include elements of vegetation.
But vegetation can also be incorporated in other genres such as the figure, interiors,
seascapes, and even cityscapes. Elements of vegetation can appear in any theme.

## Vegetation

The plant world is very rich and is composed of many species. In addition to trees and bushes, it includes vegetables, legumes, fruit, nuts, and plants in general, with or without flowers. A tree, for example, consists of a trunk, branches, and leaves, unless it is deciduous and it is autumn or winter. It can also flower. A flower has a stem, leaves, petals, etc. The artist must learn to observe and analyze the different parts that are included in a specific type of vegetation. This consists of determining its characteristic shapes and colors.

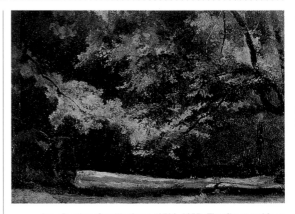

Jean-Baptiste-Camille Corot (1796–1875). The Countryside at Fontainebleau. *City Museum and Art Gallery, Bristol (USA).*

## The Still Life

This is the most useful genre for learning to draw and paint with nature. Models for still lifes often include flower bouquets, potted plants, fruit, nuts, vegetables, and legumes. All of these elements are interest-ing for their forms as well as their colors.

## Vegetation in Landscapes

Rural landscapes usually have the most vegetation.

### MORE ON THIS SUBJECT
- The horizon and planes **p. 8**
- Composition **p. 10**

### *Vegetation and the Medium*

Any medium is suitable for drawing or painting vegetation. The key is to apply the most appropriate techniques in each medium to best represent the characteristics of vegetation. With dry media, lines are used to emphasize an outline, and cross-hatching and shading in monochrome or color are used to add volume. Graphite, charcoal, chalk, or pastels can be used for this purpose. With wet media such as watercolors, gouache, ink, oil, and acrylic, brush-strokes and color areas allow the peculiarities of the specific vegetation to be represented.

*Emil Nolde. Large Poppies. Pastel. Private collection, London.*

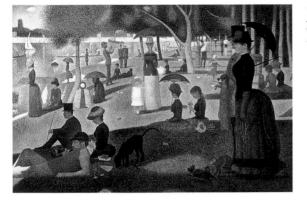

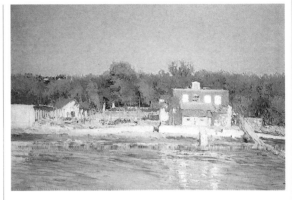

*Georges-Pierre Seurat.* Sunday Afternoon on the Island of La Grande Jatte, *1886. Oil on canvas. Art Institute of Chicago.*

Plains, whether farmed or not, have a multitude of colors. Hills and mountains, with their tree groves, underbrush, or just grass, offer the artist a variety of colors and textures. River-banks and waterfalls often have a particular sort of vege-tation. Even seascapes can have some vegetation. There can be trees by a boardwalk or brush along the top of a cliff. Cityscapes may contain trees, flower beds, or nearby parks.

## Vegetation in Interiors

It is very common to use a patio, home, or even the view through a window as a setting for vegetation or flowers. It is an ideal complement for genre scenes and lends a variety of colors and shapes to the overall picture. Indoors vegetation themes can be the central sub-ject matter, or they can be treated as a secondary element.

## Vegetation and the Figure

It is not unusual for some type of vegetation to accom-pany a figure indoors. Nor is it unusual with figures portrayed in outdoor settings such as fields or forests. In these cases, the colors of the vegetation and the figure are selected to cre-ate a coherent and harmonious whole.

*Aureliano Berruete.* The Banks of the Manzanares. *Private collection.*

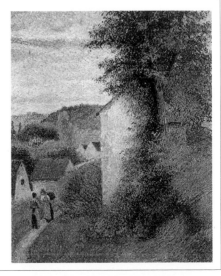

*Camille Pissarro.* The Path, *1889. Oil on canvas. Detroit Institute of Arts.*

# THE HORIZON AND PLANES

In any model for a still life, landscape, or figure study, the horizon line can be located without difficulty. No matter what the theme, different planes (or grounds) can always be distinguished. A preliminary analysis of the horizon and the plane greatly simplifies the task of determining perspective, sizes, and proportions.

## Where to Locate the Horizon

The horizon in a seascape is very easy to locate. It is the line where the sea meets the sky at infinity. It is depicted as a horizontal line.

In the case of a model, the horizon line is the intersection of the most distant vertical plane with the horizontal plane at eye level.

It is very important to be able to place the horizon line correctly once a subject has been framed. A tree in an outdoor scene can be viewed from above, as in an aerial view in which only the treetop is visible. Viewed from below—for example, from the gound looking up, the trunk, its branches, and some foliage can be seen. Artists can draw or paint sitting or standing, on an elevation, or in a hollow. No matter what or where the subject is, the horizon line must be located. Any element of vegetation will have an outline and color that correspond with the artist's vision of it. There is a perspective specific to it, whether frontal, oblique, or aerial, and this will determine the artist's rendition of it.

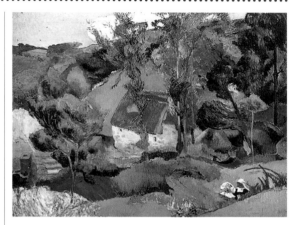

*Paul Gauguin.* The Aven at Pont-Aven, *1888. Oil on canvas. Private collection, Bern.*

### How to Proceed

Attempt to locate all the objects you can within a single vertical plane, or ground. This analysis is important because all the objects selected are related to one another by color and perspective. This way you locate on the support the background of the subject you are going to paint. You also define the objects placed in the foreground.

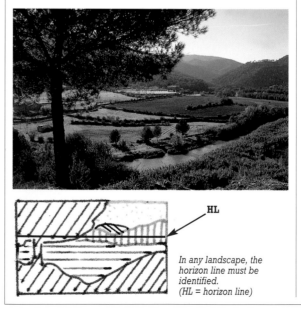

**HL**

*In any landscape, the horizon line must be identified. (HL = horizon line)*

## Distinguishing Different Planes

The model to be painted is a scene in three dimensions. The total height and width correspond to the space limited by the framing, and the different planes, or grounds, are related to depth. These are vertical planes that divide the reality of the model into sections. Let's imagine several identical objects located at different depths. The first plane, or foreground, is the closest. In it, the object is clearly distinguishable, and its dimensions are as large as the representation to scale allows. A little farther

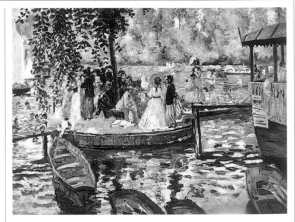

*Pierre-Auguste Renoir. La Grenouillière.*
*Oil on canvas. Musée d'Orsay, Paris.*

*Claude Monet. La Grenouillière.*
*Oil on canvas. Musée d'Orsay, Paris.*

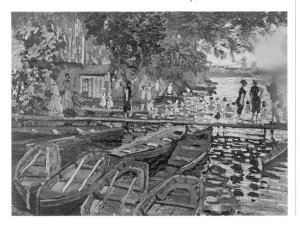

lines of objects are drawn as if in cross section in corresponding proportions. A plant appears large in the foreground. A tree in the middle ground appears smaller than the plant yet larger than a group of trees located in the background.

**MORE ON THIS SUBJECT**

· Vegetation in themes **p. 6**

*Vincent van Gogh.* View of Arles, *1888. Oil on canvas. Rijksmuseum, Vincent van Gogh, Amsterdam.*

from the painter is the theoretical middle ground. In it, any object that is the same size as one located in the foreground appears smaller. In the last plane, which in a landscape would be the plane of infinity, another object identical in size to the first would not even be perceptible.

## The Different Planes and Representations

Graphic representations are very useful for comprehending how to analyze a model. In each vertical plane, the out-

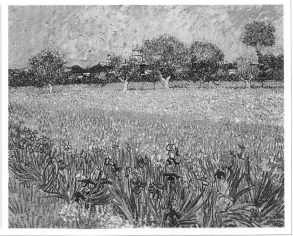

# COMPOSITION

The composition of a theme must be related to the way it is framed. The different objects are distributed throughout the space in a particular manner. When the overall impression they produce is appealing and interesting, the composition is considered successful.

## The Art of Composition

In art everything is subjective, including the composition. But certain norms ensure good results. Compositional schemes are very simple but highly effective. The principle of balance of masses can be used to choose an effective point of view. There is always some element that becomes the center of interest, whether because of its shape, or its color, or both. This element becomes even more prominent when placed in the so-called golden section.

## Framing

In models with vegetation in open spaces, the artist normally builds a simple cardboard frame that he moves until he finds a pleasing setting. Moving the frame around is a way to "balance" the color masses of vegetation, in other words, to modify their impact within the framed area. Almost instantly, simple shapes can be

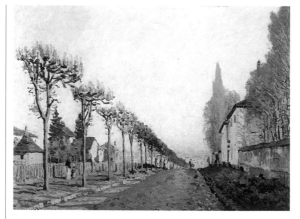

*Alfred Sisley. The Path to La Machine, Louveciennes, 1873. Musée d'Orsay, Paris. The framing and composition lead to this perspective, with its obvious single vanishing point.*

### The Focus of Interest

The focus of interest is undoubtedly the most important element in a painting. It is often accentuated. Everything in the composition should emphasize it. In fact, the focus of interest is achieved when the observer's eyes are instinctively drawn toward this focal point. To achieve this, the compositional scheme and the golden section are used, along with the directions provided by the elements surrounding it.

recognized within the framed space.

*A theme such as this one, with a sunflower field in the foreground, can be delineated with the help of an easily constructed frame.*

### Compositional Schemes

Very common compositional schemes appear in the shapes of ovals, triangles, "L's", trapezoids, etc. The simplest one is the linear composition. The focus of interest lies within the chosen shape of the compositional scheme.

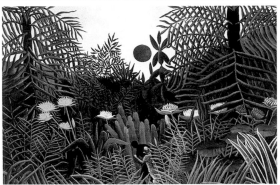

*Henri Rousseau.* Landscape with Sunset. *This painter experiments with a composition that plays with the symmetry-asymmetry binomial.*

*Joaquim Mir.* Village on a Hillside. *Museu d'Art Modern, Barcelona. The vegetation in this painting is placed in a diagonal composition.*

## The Balance of Masses

The real dimensions of a plant, when transferred onto a representation in the appropriately scaled proportion, are adapted to fit within a limited area on the support. This surface is covered with a concrete mass of colors. A frame should ensure that the distribution of the color masses of the vegetation and of the remaining objects appear to be in balance.

The representation of the balance of masses is done with the use of a graphic based on the idea of a balance showing the weights or chromatic masses.

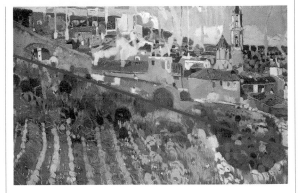

### MORE ON THIS SUBJECT
• Vegetation in themes **p. 6**
• The horizon and planes **p. 8**

## The Golden Section

Also called the golden mean, the golden section is an area of great importance within the surface of the support. It has four golden points as vertices.

Any composition in which the center of interest and a large part of the scheme lie within this golden section is successful.

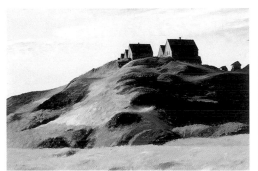

*Edward Hopper.* Corn Hill. *Oil on canvas. The focus of interest (the group of houses) is located above the golden section. Interest is added by the rising hillside in a trapezoidal composition with an exquisite palette.*

*The so-called golden section is easily located on paper or canvas. The length and width of the painting is multiplied by 0.618 and the corresponding distances are measured from each vertex.*

# THE FOREGROUND

From a close distance, every detail of vegetation is readily distinguishable. All of the elements in the foreground have great definition of shape, high contrast of color, and tonal variations. Studying every detail is the first step in determining how best to represent it.

## Characteristics of Vegetation

Every element of vegetation is unique. A leaf, a tree trunk, a branch, a flower, and any component of a plant, has specific characteristics. For example, a leaf has a particular shape and vein distribution. A flower has several distinct features, such as the shape of its petals and their distribution around the crown. Observing the shapes and colors of each component is a preliminary step.

## Pictorial Synthesis

When observing an element of vegetation, the eye focuses

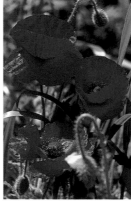

*In extremely close foregrounds, elements of vegetation are brought into sharp focus, like these poppies that appear in all their splendor.*

| MORE ON THIS SUBJECT |
|---|
| • The middle ground **p. 14** |

on a single point of interest. The essential thing in a drawing or painting is to find a way of expressing enough features

to identify the plant. It usually involves a certain degree of synthesis.

## The Drawing

A shape can be captured through a drawing that basically outlines the figure. A few more lines, just those necessary, can be added to illustrate details.

*Artists lend great importance to trees. In this painting, an initial roughing-out is applied in watercolor.*

*On this watercolor base, the artist adds more paint to develop volume and provide a more detailed rendition of the tree.*

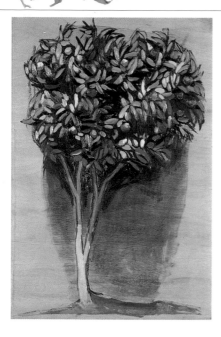

*An orange tree in the foreground filled with leaves and fruit allows for a contrasted palette in oil. Sketch by Esther Olivé de Puig.*

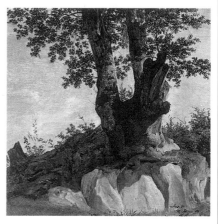

*Heinrich Reinhold (1788–1825).* **Study of a Tree.** *Kunsthalle, Hamburg. Most artists have some works that constitute monographic studies of trees.*

It is not enough to study the characteristic features of an element of vegetation. Its position in space must be assessed. A leaf, for example, does not always appear in the same perspective. All of the spatial positions can be found in a landscape. The outline of a figure and the lines inside it must be studied individually to determine how they fit into the perspective in question.

## Color

In a color analysis, the following question must be answered: What is the color like? If we are dealing with a green leaf, we should be able to determine whether it is a bluish green, a yellow-green, etc.

If we are studying a flower, we should be able to determine whether the pink of its petals has yellow overtones or carmine hues, etc.

The artist must establish the color group and use primary, secondary, and tertiary colors for orientation. It is more difficult to create dull or "muddy" greens, which require complementary colors.

## Contrast in the Foreground

In a sufficiently strong light, the elements of vegetation that appear in the immediate foreground can be clearly distinguished. The definition of their forms, color, and tonal values is complete and there is a high degree of contrast.

In undertaking a painting with elements of vegetation, preliminary studies are indispensable to analyze the characteristics of the linear components as well as the tonal values.

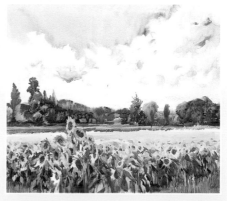

*Vicenç Ballestar.* **Untitled.** *The sunflowers in the foreground are highly differentiated from the more distant ones.*

# THE MIDDLE GROUND

The vegetation that we see somewhat farther away, in what is commonly referred to as the middle ground, has shape and color characteristics different from what we would see if it were very close. The features necessary to express their nature convincingly must be determined.

## Characteristics of the Middle Ground

In a close-up view of a tree, the trunk, some branches, and some leaves are clearly distinguished. From farther away, only the treetop and the trunk are clearly visible. A flower up close has very distinct petals, stem, and leaves. From far away it is a speck of color on a tinted background.

The characteristics of the middle ground or of successive intermediate grounds must be determined with regard to the general lines or forms of the overall subject, and with respect to its color quality.

## Synthesis Is Essential

The principle of synthesis is absolutely essential. It is impossible to represent all of the elements in the middle

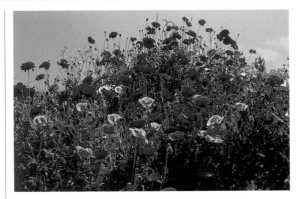

*A field of poppies seen from a distance could look like this. The flowers are no longer as detailed as those closer up.*

*From an even greater distance, the flowers become tiny yellow, pink, or red dots that stand out amid a green background.*

*In this sketch by M. Gaspar, the right foreground has been left unpainted. With the exception of the sky and mountains in the background, the rest of the work consists of several intermediate grounds.*

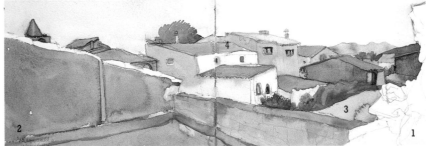

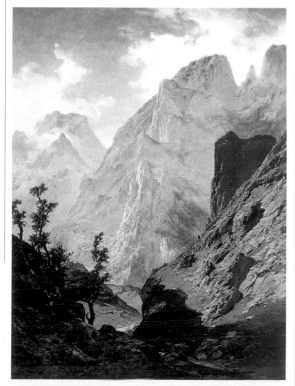

*This brushstroke provides the degree of synthesis appropriate to the distance and realistically portrays the difference between a pine tree and some cypresses.*

## Synthesis and Detail

What is the most appropriate degree of synthesis? Upon excessive simplification of features, you can cause the disappearance of the elements that identify the vegetation. There is, therefore, an optimal balance between synthesis and detail, and this balance lies in the middle ground. The ratio between synthesis and detail is different for the different planes. In practice, there must be a clear difference between the representation of the middle ground, or of successive intermediate grounds, and the background.

ground. Indeed, this is hardly possible with the foreground.

There is a simplification of both forms and colors. In the distance, a field with wild anemones appears as an extension of green, dotted here and there with the colors of the flowers. At a greater distance, the points of colors cannot even be perceived. The green of the meadow takes on a different—almost brownish—hue. This optical color mixture occurs at substantial distances, and is created by our eyes.

### A Softer Contrast

Vegetation that appears in the middle ground has a softer contrast than vegetation in the foreground. Even on a clear day, the effect of the atmosphere is evident. This phenomenon is more visible on cloudy days. Between the viewer and the middle ground lies a mass of air with particles in suspension. An infinity of reflections and refraction of light come into play that cause all sorts of optical phenomena. Colors are subdued by these effects.

**MORE ON THIS SUBJECT**
• The foreground **p. 12**

*Carlos de Haes. The Picos de Europa. Oil on canvas. The artist masterfully interprets the effect of the atmosphere on the different grounds. The expression of depth is extraordinarily successful, in part accentuated by the foreground in silhouette.*

# THE BACKGROUND AND INFINITY

Every scene has a background that depends on the characteristics of the model. It can be a relatively close ground or infinity. When dealing with infinity, the degree of imprecision is very high and contrasts diminish.

## Vegetation in Infinity

Not even a tree can be distinguished in infinity. A mountain with all its vegetation becomes a blur of more or less uniform color with a general outline. These are the matters that are of pictorial interest in a background. With regard to the drawing, the most important thing is the outline of the meadow, hill, or mountain with its vegetation. With regard to color, it is important to be able to describe its characteristics, especially in relation to the foreground and middle ground. There are characteristic profiles and colors in infinity.

*In a landscape such as this one, the most distant element is the mountainous mass outlined against the sky. What allows it to be described is its contour and the color that makes it visible.*

*A field of poppies at a great distance can be seen as an area of reddish color.*

## Learning from Masters

In all the works by great masters, you can observe the differentiated treatment of the spaces in a painting corresponding to the foreground, middle ground, and distant grounds or infinity. It is important to learn to see the reality of the spaces around us, as well as studying each artist's approach. Keep in mind the absolute subjectivity underlying all works of art. The creative process combines personal tendencies and interpretation in determining a color palette and the subsequent harmonization.

The best approach is to directly observe the original works by masters. Photographic reproductions do not usually show all of the significant details in an analysis. It is always possible to access great works of art by visiting museums and art galleries.

## The Effects of the Atmosphere

In the middle ground, it is more difficult to detect the effects of the atmosphere. This is not true of infinity. Colors always appear less intense, washed out, and the definition of profiles is low, with little contrast. You can imagine that to represent this ground you will have to apply the most

*Louis Gauffier (1762–1801).
Landscape at Vallombrosa. The
different grounds of this
landscape are defined through
palette work that produces the
appropriate contrasts and
intensities.*

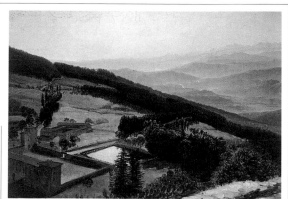

**MORE ON THIS SUBJECT**

- The foreground **p. 12**
- The middle ground **p. 14**
- Light and distance **p. 22**

appropriate drawing or painting means to achieve the desired effect.

## The Degree of Imprecision

What is the color of a mountain area with vegetation seen from a distance? The predominant colors are pinks, earthen tones, browns, bluish tones, violets, greens and grays, all very muted. These colors have lighter tones than those appearing in the middle and foregrounds. A special sensitivity must be developed to capture the subtle nuances.

## Depth

How can we depict vision being lost in infinity? A drawing in the proper proportion indicates the existence of elements of vegetation belonging to the different grounds.

Size is an indicator of depth. The perception of the degree of imprecision in outlines is another significant step.

Finally, with relation to color, imprecision matches that of the lines and is enhanced with nuances.

### What to Look For

What is the appearance of the sky when it is present in a model? Its colors and their gradations must be determined. The qualities of this sky will be reflected in the colors of the vegetation. As we will see later, the type of light influences the colors of each element of vegetation. Everything is important in a pictorial representation. Each space of the painting must be drawn and colored maintaining a harmonious relation with all the others.

*Paul Gauguin. Les Alyscamps, Arles, 1888.
Oil on canvas. Musée d'Orsay, Paris. When it
appears in a landscape, the sky is the most
distant element. It is very interesting to note
the texture with which the artist represents it.*

# COLOR IN VEGETATION

When we observe vegetation, an infinity of colors can be seen. Any element of vegetation has the characteristic colors of each of its components. However, upon seeing the vegetation as a whole, much more than its characteristic colors can be perceived. At this point, the concept of atmospheric color must be introduced.

## Characteristic Color

Characteristic color is understood as the color unique to an element of vegetation. This characteristic color can only be perceived through our visual organ, the eye, due to the atmospheric light that illuminates it. In a hypothetical case when neutral light is cast upon an isolated element, only the element's characteristic color and its tonal values in a grada-

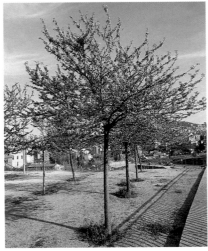

*Vegetation can have many different colors.*

tion from light to dark would be seen.

**Characteristic color and light.** It is important to determine the chromatic qualities of a characteristic color. To train the eye, one could, for example, observe a potted plant in an artificially lit interior. Then it could be observed in a type of light with different chromat-

ic characteristics, such as natural sunlight on a sunny day. Comparisons are easier that way, and the nuances adopted by the characteristic color can be seen.

A palm tree whose leaves under artificial light appear blue-green, for example, might appear yellow-green under the midday sun.

## Atmospheric Color

If the light illuminating a scene is strong, then the various characteristic colors of the elements of vegetation that are juxtaposed will be strong as well. The phenomenon of atmospheric color can be clearly perceived in all planes. There are several aspects on which to base the color analysis, namely simultaneous contrast, tinged adjacent colors, highlights and reflections (their

*Every element of vegetation has its own "green."*

qualities), and the nature of shadows.

**Simultaneous contrast.** Simultaneous contrast is the contrast arising from juxtaposed colors. A light color appears lighter when surrounded by a darker color, while a darker color appears darker when surrounded by a lighter color.

**A color is tinged by another.** Tingeing also occurs when the atmospheric color mixes with juxtaposed colors. This phenomenon is in reality the influence of the predominant color together with the quality of light. Placing two colors next to one another results in a tingeing of both, each one affecting the other.

### The Color of Shadows

The qualities of an object's own shadow are analyzed as tonal values of the object's characteristic color, influenced by the atmospheric color. The qualities of a shadow are basically those of the characteristic color of the object which is casting it.

The color of the object casting the shadow influences it or is reflected in it. The appropriate tone of projected shadows in a representation is crucial to the expression of depth. The projected shadows must be located in the different grounds, whether foreground, middle ground, or background.

*The color of choice for painting vegetation is obviously green.*

## Highlights and Reflections

The surfaces of many elements of vegetation are smooth and reflective. Dew, rainwater, etc. can enhance the possibility of reflection. Highlights and reflections are not just the result of tingeing on characteristic colors. In a reflection, the characteristic color of the element being reflected appears with slight nuances. These surfaces have areas or points of maximum illumination, and learning to locate them could be very interesting.

## Shadows

The model must be analyzed and in each case, the source of the shadows must be studied. There are two different types of shadow.

**An object's own shadow.** An object's own shadow is the shadow that is cast from it as the result of light striking it directly.

**A projected shadow.** A projected shadow, on the other hand, is the dark area that results when the shadow of one object is projected onto another causing the first object to interfere with the illumination of the second.

*Van Gogh.* Bed of Irises, *1889. The artist seeks harmony through a palette of greens. Color, tone, texture, and rhythm express the form and volume of all elements in this plant scene.*

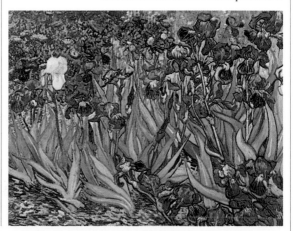

# LIGHT

Without light, colors are not visible. The type of light that illuminates vegetation makes the vegetation appear in concrete colors that are directly related to the light. When undertaking the analysis of vegetation, it is essential to study the source, intensity, and chromatic quality of the light that bathes it.

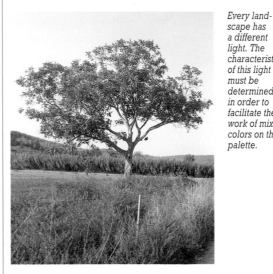

*Every landscape has a different light. The characteristics of this light must be determined in order to facilitate the work of mixing colors on the palette.*

**Natural light.** The light of the sun, moon, or the stars is natural light.

**Artificial light.** Electric light and the light from a candle or street lamp are artificial light.

**Source.** Light can come from a variety of sources and directions. There is overhead light, diffuse light, direct light, frontal light, and side light. When vegetation is seen illuminated from behind, or backlit, it is called semi-silhouette or full silhouette.

**Quality.** Depending on the time of day, the season, and the weather, natural light can range from yellowish to bluish. Artificial light is commonly used as a source of illumination for house plants. It can be bluish, neutral, or have an orange tone.

**Intensity.** The sunlight at noon on a summer day can be blinding, whereas the light on a cloudy winter's day is weak.

## Characteristics of Light

The light that illuminates the model is a determining factor. Any changes in the light will modify the system of light and shadows, and the same vegetation will appear different. There are various types of light as well as other factors.

## Light and Its Trajectory

The effect of light on vegetation makes illuminated zones stand out while others lie in progressively darker shadow. To find the trajectory of light, the areas of light and shadow must be located, and the logical relationship existing between them established. For example, which element casts a shadow onto another? In fact, it is best to establish the origin of every projected shadow and locate the areas of greatest and least intensity of light.

*Shadow and silhouettes provide contrast with more intensely illuminated areas. This is what guides the painter in applying mixed colors onto the canvas. Watercolor by Vicenç Ballestar.*

**MORE ON THIS SUBJECT**
• Light and distance **p. 22**

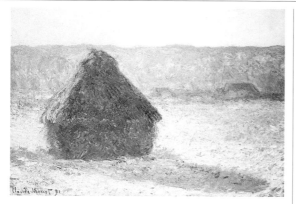

*Claude Monet (1840–1926).* Haystack in Winter. *Oil on canvas. The light phenomenon described by Monet makes use of an exquisite palette to represent the line of vegetation hardly perceptible in a distant plane behind the haystack.*

shrub, each plant, moss, ferns, etc., has its own shade of green. Dark or light, yellowish or bluish, fresh or faded, it is a good idea to train yourself to discern these differences.

However, vegetation can have many more colors apart from greens. Flowers, for example, can be any color. A wheat field lies within the family of yellows, ochres, and oranges. In nature, any color can exist.

But above all, bear in mind that the quality of light illuminating vegetation that is in reality green can make us see it in very different colors, such as yellows, brownish-ochres, bluish tones, violets, etc.

## The Artistic Value of Light

Diffuse light casts soft shadows on vegetation. Direct light, on the other hand, provides strong illumination and creates intense contrasts between light and shadow.

Frontal light eliminates projected shadows or reduces them to a minimum. When it acts on vegetation, it is difficult to differentiate tonal values. The shadows of an element of vegetation as well as shadows projected on the whole grow in lateral light.

The silhouette is very artistic. When vegetation is backlit, this suggests a common link among all of the forms in shadow, sharply outlined by strong light.

## Light and the Color of Vegetation

Characteristic color, tonal and reflected colors, and the color of shadows in a plant scene depend on the light cast on them. Each tree, each

*A bright day calls for light greens. Even in the shade, the greens are bright. Watercolor by M. Gaspar.*

*Jean-Baptiste-Camille Corot (1796–1875).* La Serpentera. *Corot's realism is based on a warm palette of greens, earth tones, and pale ochres. The artist focuses on the values of characteristic colors, tonal colors, and projected shadows in a very harmonious manner.*

# LIGHT AND DISTANCE

The light illuminating vegetation affects the view we have of it. The colors that are seen must be analyzed accordingly. The effect of the atmosphere and the distance changes drastically according to the type of natural light and the accidental or typical seasonal weather conditions.

## Colors at a Close Distance

Suppose we observe vegetation up close. Its color is influenced by the quality of light illuminating it. In the foreground, contrasts are intense and outlines are clear, as light conditions allow.

*The chromatic characteristics of the light that illuminates a scene determine how the colors of each element of vegetation will be perceived in each of the different grounds.*

### The Colors of Night

Under nocturnal light, plants acquire very peculiar colors. The colors perceived have a great deal of blue, the basic color of darkness. The bluish-gray or violet sky casts a light on the vegetation that simplifies all of its details. Many silhouettes appear, and details of the contrasts tend to be minimized. All of the colors that can be seen in the vegetation are bluish or purplish, browns, very dark grays, and even blacks. The analysis, nonetheless, is always done in the same manner, that is, the source of light is studied, as well as its quality and its trajectory. Everything appearing in silhouette is a great mass of dark color set off against the surrounding light.

## Predominant Color

It is not always easy to recognize the characteristics of the predominant color that the light casts on vegetation. This skill of perception must be learned.

When the light is yellowish-white, orange, pink, or reddish, it is called a warm light. When it is bluish, violet, or grayish, it is referred to as a cool light. The season of the year and the hour of the day provide good guidance. On a splendid, sunny summer day at noon, everything is bathed in a strong, blinding white light. In winter on a cloudy day, the light can be very cool. All the vegetation appears bluish or grayish.

*David Hockney. The Valley. Oil on canvas. In this work, there is an exhaustive study of the treatment of the different grounds to describe the effect that the light creates on each of them.*

## Colors in the Distance

Depending on the light and the quality of the atmosphere, colors that tend to fade in the distance can be affected even more. It is no wonder that the majority of painters devote a great part of their time to the study of light and atmosphere.

In order to learn the effect that this produces on vegetation, you first have to observe what you see.

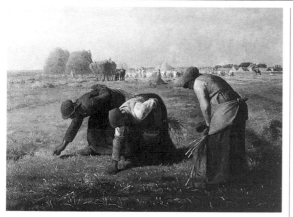

*Jean-François Millet.* The Gleaners, *1857. Oil on canvas. The predominant color is warm from the sky to each different ground.*

## Light and the Atmosphere

Weather conditions influence the perception of vegetation. Light travels through the atmosphere and interacts with the particles suspended in the air to create a play of reflections and refraction of light.

Water vapor (fog), drops of water (rain), grains of sand, spores, and many other particles (transported by the wind or the interaction of cold and warm fronts) constitute what we might call intermediate atmosphere.

Therefore, atmospheric conditions must be added to the predominant color that the light lends, limiting even more the definition of forms and colors in the distance.

*The artist can express the effect that fog produces on our perception of vegetation through the appropriate techniques. In this case, Vicenç Ballestar uses watercolor wet on dry.*

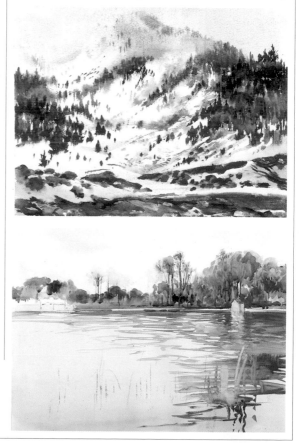

### MORE ON THIS SUBJECT

· Light and distance **p. 22**
· The palette **p. 26**

*For vegetation to appear clearly despite its distance, Vicenç Ballestar uses wet on dry to capture it.*

# COLOR THEORY

Manufactured paints are commercially available. These consist of pigments that are bound with a medium whose characteristics give the paint its name. Despite the extensive range of colors offered, to represent the colors of vegetation the artist must have some knowledge of color theory in order to create the appropriate mixtures.

○ + ○ + ○ + ○ = ○ + ○ = ○

*This is the ratio of proportions for the creation of secondary and tertiary colors from primary ones. The small circle represents a primary color, the medium-sized circle a secondary color, and the large circle a tertiary one.*

## Pigment Colors

The term pigment colors is used in reference to manufactured paint, which comes in a wide range of colors. The color of these paints is produced by pigments, which are substances reduced to a powder. These pigments must be bound with some medium to facilitate their application. The agent used to dilute the substance binding the pigment or pigments gives rise to the generic names. Hence, oil paint is a medium whose binding agent is oil; watercolor is a medium whose binding agent is water, etc.

**MORE ON THIS SUBJECT**
• The palette **p. 26**
• Vegetation: drawing and color **p. 50**

## Primary, Secondary, and Tertiary Colors

The artist attempts to reproduce on the palette those colors he/she sees in vegetation. Beginning with only three colors, those called basic or primary, and mixing them, one can create practically all colors. With some media (such as oils, acrylic, gouache) white needs to be added as well, but not with watercolors.

In the European system, which is similar to the one used in color printing in the U.S., the three **primary colors** are yellow, magenta, and cyan.

The three **secondary colors** are obtained by mixing the primary colors in pairs in equal amounts. The secondary color red is created by mixing yellow and magenta. The secondary color green is obtained from yellow and cyan. Blue (or purple) is created by mixing magenta and cyan.

There are six **tertiary colors** which are obtained by mixing a primary color with a secondary color in equal amounts. If we reduce every-

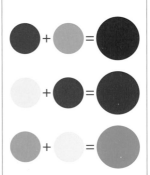

*Graphic explaining the formation of the secondary colors blue (or purple), red, and green from the primary ones of yellow, magenta, and cyan.*

thing to mixtures of primaries, a tertiary color is formed from 25% of one primary and 75% of another primary. The tertiary color orange is created from 75% yellow and 25% magenta. The tertiary color deep red is created from 25% yellow and 75% magenta.

### An Infinity of Colors

The procedure for obtaining secondary and tertiary colors from the three primary colors suggests that, when the proportion of a primary color used in a mixture is modified, many more colors can be created within each group. A yellow can become progressively more orange, a red more yellowish, a dark red more purplish, a yellow can show a tinge of green, a mauve can develop into a very reddish violet, etc.

With highly differentiated proportions of all three primary colors mixed at once, or of pairs of complementary colors, an infinity of colors can be achieved, such as ochres, earth colors, browns, neutral greens, grays, etc.

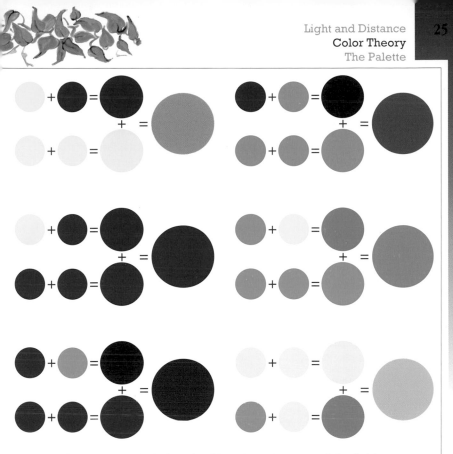

*Graphic that explains the formation of the tertiary colors (orange, dark red, violet, violet-blue, blue-green, and yellow-green) from the secondary (red, green, and blue or purple) and primary colors (yellow, magenta, and cyan).*

The tertiary color violet is obtained from 75% magenta and 25% cyan. The tertiary color violet-blue is obtained from 25% magenta and 75% cyan. The tertiary yellow-green is made of 75% yellow and 25% cyan. Blue-green is obtained from 25% yellow and 75% cyan.

### Neutral Colors

In theory, when the three primary colors are mixed in equal amounts, the color black is produced. When they are mixed in unequal amounts, subdued and "muddy" colors are produced, known as neutral colors.

Theoretic black can also be created by mixing a secondary color and the primary one that was not used to create it.

Similarly, neutral colors can be made by mixing unequal amounts of a secondary and the primary that was not used to create it. The complementary colors can be arranged in pairs. The most well-known are primary yellow and secondary blue, secondary red and cyan blue, and magenta and secondary green.

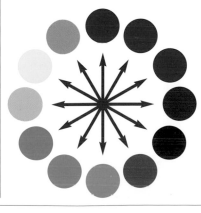

*The primary, secondary, and tertiary colors can be arranged in a circle called the color wheel, on which complementary colors are diametrically opposed.*

# THE PALETTE

In any color medium, there is a minimum range of colors available that is wide enough to allow a subject to be painted with every nuance. All of the manufactured colors selected by an artist for a particular vegetation theme constitute the palette. These color groups are categorized according to their "temperature," that is, warm, cool, and neutral.

## The Universal Palette

Although one can paint using only the three primary colors, the results are not always satisfactory. Painters always end up working with personalized palettes of various colors. But when beginning to paint, yellows, reds, blues, greens, earth colors, and browns are needed. Two of the following yellows can be chosen: lemon yellow or light, medium or deep yellow. There are many reds on the market, but the most popular is a deep red or vermilion, and a deep madder lake. Those interested in floral motifs will also need an orange. For earth colors, a yellowish ochre, sienna, and burnt sienna, as well as umber and burnt umber are suggested. For blue colors, sky blue, turquoise, ultramarine, and Prussian blue are the most common, but the artist can start with just two: one dark

*Watercolors can be mixed to obtain pure or neutral colors.*

and one light. The basic greens are light green and emerald green.

## On Black and White

A medium such as watercolor, which is based on its transparency on white paper, does not need white paint. But oil, gouache, and acrylic are opaque media in which white is indispensable to achieve tones.

With regard to black, although it is useful to have a type of black such as smoke black or ebony, it is not essential. It is not a good idea to use it to darken colors, that is, to mix with other colors as the results are usually very dirty, especially in oil.

## Mixtures and the Medium

Color theory is applicable to any medium. Depending on the medium, blends can be created by thoroughly mixing the paints on the palette, or directly on the canvas by using techniques to create an optical mixture, superimposing layers of different colors, or using mottling or frottage techniques.

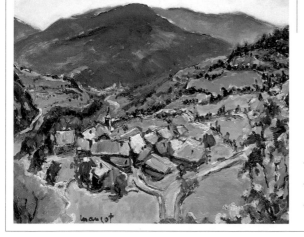

*The artist Montserrat Mangot painted this landscape with vegetation using a palette of primarily cool colors: greens and blues. There is a touch of yellow to lighten the greens as well as some carmine to create the purples in the background.*

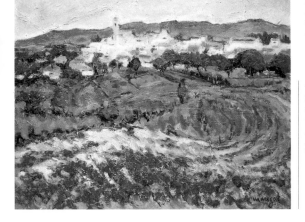

*In this landscape, the artist Montserrat Mangot seeks contrast between warm and cool colors.*

can choose yellow and blue, red and blue, or red and green. These two complementary colors are mixed in unequal amounts and, in the appropriate media, white is added as well.

## Harmonic Color Ranges

No matter what type of mixture is being used, homogenous or optical, what really matters is the major color scheme that the representation offers as a whole.

The complete harmonic color ranges are the warm, cool, and neutral ranges. To work with the warm range, simply include warm colors in your mixtures.

Cool colors are only used to add hues to these warm mixtures. In a cool complete harmonic range, primarily cool colors are used, that is, blues and greens.

Warm colors can be used in a cool range to add hues. The neutral harmonic range has a highly subtle range of hues and is created from pairs of complementary colors. You

### The Artist's Interpretation

Harmonization and interpretation are usually related. Reality does not always offer scenes in which there is an evident harmony of colors. Nature has contrasts which the artist's eye may consider too harsh. The need may arise to alter something through color. This can be considered interpretation.

*This is a sample of the delicate harmony of a range of warm neutral colors.*

**MORE ON THIS SUBJECT**

· Color theory **p. 24**
· Vegetation: drawing and color **p. 50**

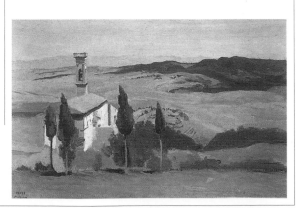

*Jean-Baptiste-Camille Corot (1796–1875).* Volterra, Church and Steeple. *This is Corot's characteristic palette, based on warm neutral colors.*

# TEXTURE UP CLOSE

All surfaces of an element of vegetation, in addition to color, have some relief. Speaking in pictorial terms, there is a texture that allows the realistic representation of each type of surface and relief. To achieve a specific texture, a series of procedures appropriate to each medium must be used.

## Surfaces and Textures

Up close, all surfaces are perceived in great detail. The trunk of a tree is usually rough. Some leaves look very smooth, while others have a velvety texture. A pine cone and an artichoke have relatively similar shapes but very different textures. The former is similar to bark, whereas the latter is more like a plant with leaves.

## Implements to Create Texture

How can texture be represented? It is not just a matter of color, but also how it is applied. Every implement in the chosen technique allows a different effect.

A smooth surface calls for a homogeneous mixture for its representation. The bark of a

### Each Medium Has Its Own Techniques

Any medium can be used to represent vegetation. But in practice, there are very clear differences between oils, watercolors, acrylics, gouache, and pastel.

In this sense, there is a stage of analyzing the vegetation that is special for each medium. The second stage of the analysis studies the different steps to be taken according to the chosen medium. There is a series of techniques appropriate to each medium. For example, blending is used in dry media. The objectives common to all media, such as creating a blend, involve a different procedure adapted to the possibilities of each medium.

eucalyptus suggests the use of a palette knife when working in oil. The voluptuous nature of a petal indicates the need for a fan-shaped brush in acrylic or oil in order to create transparencies and layers and emphasize the volume.

**MORE ON THIS SUBJECT**
- Texture at a distance **p. 30**
- Vegetation: drawing and color **p. 50**
- Vegetation: texture and rhythm **p. 52**

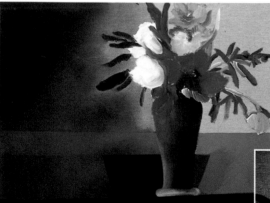

*One approach to creating textures consists in studying foregrounds indoors—a still life with flowers, for example. The difficulty of capturing light is reduced with exteriors.*

*In this enlarged detail, we can see the mottling from the texture of the paper, the blending, and the direction of the brushwork.*

## Highlights

Contrasts in the foreground are primarily created by the use of simultaneous contrast. This principle holds that a color appears lighter when surrounded by a darker color, and darker when surrounded by a lighter one. These contrasts interact in a simultaneous fashion.

**The importance of outlines.** Highlights can be created in drawing or painting by using, in addition to simultaneous contrasts, the force of outlines. To express contrast in a foreground, backlighting is used, creating a darker area in silhouette in the foreground to highlight a light inner area; or outlines in lighter colors can be used to set off a dark inner area.

## The Sequence of Procedures

The techniques used should be appropriate to each case. The sequence of steps must be studied. As an example, let's look at some aspects of watercolor and oil.

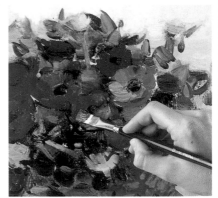

*The paintbrush is an instrument controlled by the pressure exerted on the handle by the fingers. Gesture is transmitted by the movements of the wrist and hand. Shape must be modeled.*

**Watercolor.** A medium such as watercolor calls for working with darker tones on light, so that the order of color layers and their application must be determined before applying the paint. When a brushstroke is applied over an area of wet paint, one result is obtained, whereas another is obtained if applied over an area of dry paint. To achieve the latter, the artist must wait for the appropriate drying time.

**Oil.** In order to use oil as a first layer in a bright trans-

parency, the canvas can be painted with white gesso to increase its brightness.

If oil is worked in an opaque manner, it can be applied in light over dark or vice-versa, and wet paint over wet paint or wet on dry. If we want to create texture to achieve a mottled effect, the two colors that are to interact should be moist and applied in thick layers, one over the other with the palette knife.

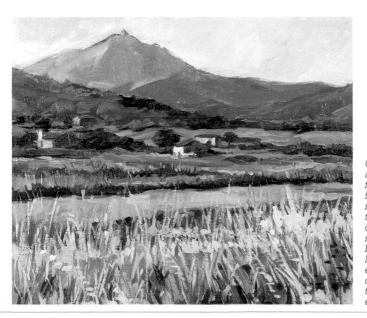

*Grass, bushes, and wheat in a field in the foreground require texturing to describe them realistically. The brushwork by Miguel Ferrón is extensive in order to achieve the desired effect.*

# TEXTURE AT A DISTANCE

It is very difficult to perceive the textural characteristics of vegetation located on an intermediate plane. The painter's objective is to represent volume in middle grounds using the procedures most appropriate to each medium. The visual impression left by the application of color must have the degree of imprecision required.

## Texture and Imprecision

For middle grounds, in which the degree of precision and contrast diminish both in shapes and colors, textures must promote that impression. Gradations are often used, as well as mottling and frottage. In each medium there are instruments more suitable than others for achieving the desired texture. Hence, not only must the suitable techniques be chosen, but the tools to carry them out as well.

## Degree of Synthesis

The application of color depends on the degree of synthesis required in the representation of the middle grounds. The different treatment becomes apparent in the work of a landscape artist. If we observe a tree in what might be the first middle ground, we see a certain degree of synthesis. The synthe-

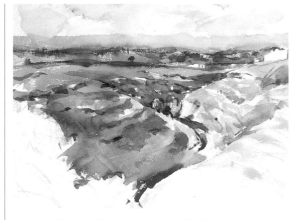

*When working with watercolors, the background is painted first. Contrasts and texture correspond to the treatment that the vegetation requires at a distance.*

sis increases with distance. This is how depth is expressed in a landscape.

## Fewer Highlights

Simultaneous contrasts should decrease in intensity as depth increases. A dark background around a lighter color will be lighter than one placed in the foreground so as to produce a lesser contrast.

Inversely, the light color in the center of the contrast area will be darker than one in the foreground in order to create a softer contrast with the surrounding area.

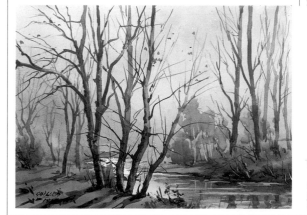

*Guillem Fresquet. Untitled. In this work, we can see the different treatments Fresquet gives to the vegetation in various grounds.*

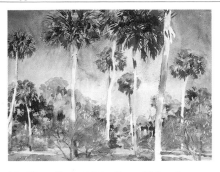

*Some painters do not make much effort to represent depth. Without creating a completely flat painting, they simplify texture without sacrificing visual impact. Watercolor by M. Gaspar.*

*John Singer Sargent. Palm Trees. Watercolor over graphite on white paper. The texture needed to express depth is created through mixtures according to the predominant color of the light.*

## Color and Less Precision

The intensity of colors diminishes with distance. With regard to the palette, this means a profusion of mixtures with the use of white (in oil, acrylic, gouache, and pastel) and tending towards neutral colors. In watercolor, this involves the use of special techniques, such as painting on wet paper or semi-wet paper.

## Texture in Infinity

Vegetation seen in infinity constitutes a case of maximum imprecision. The most appropriate technique is the use of gradations, but frottage is also useful.

The outline of any type of vegetation on the horizon or in the far distance is that of the mountain, hill, or meadow on which it is growing. What matters is the relative contrast

### The Procedure with Each Medium

There are techniques in each medium to capture the characteristic imprecision of intermediate planes. In oil, this is usually done through the application of paint in the second stage over a still moist underlying layer. If the previous layer is already dry, outlines can be given definition with moist paint and no impasto, or even through frottage. In watercolor, paint is applied in superimposed layers in which the first layer is totally or partially dry.

between the surface of the paper or canvas and the sky. There should be low contrast in the definition of shapes and colors.

Watercolor is a medium whose immediacy allows the expression of texture in infinity.

| MORE ON THIS SUBJECT |
- Texture up close **p. 28**
- Vegetation: drawing and color **p. 50**
- Vegetation: texture and rhythm **p. 52**

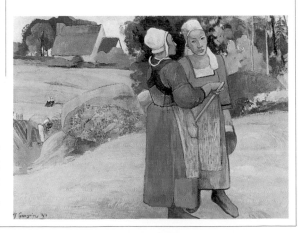

*Paul Gauguin. Breton Peasant Women. The artist, in his first steps toward synthesis, treats the different planes with flat and compartmentalized colors to represent vegetation. Nonetheless, different textures can be observed.*

# THE PRELIMINARY SKETCH

After observing the subject containing vegetation and carrying out the relevant analysis of the sequence of procedures to be followed, we move on to the practical representation stage. On the support appropriate to every medium, the representation is generally begun with a sketch, which is executed in the most suitable medium, or even directly with the brush.

*The sketch for painting an almond tree branch in bloom requires only a few lines. It is important to remember that the twigs are always smaller than the branches from which they stem.*

## Framing

The framed subject is limited in space. To represent the subject on a support, the ratio of proportions must be established between the real size of the elements of vegetation that we see and their size once we transfer them onto paper or canvas. To facilitate the framing process, a small frame can easily be constructed using a square and scissors. Before drawing or painting the sketch, several measurements must then be taken.

*Even in a sketch, a cypress tree must be distinguishable from a pine or a eucalyptus. However, the color and tonal values later applied will characterize the tree more accurately.*

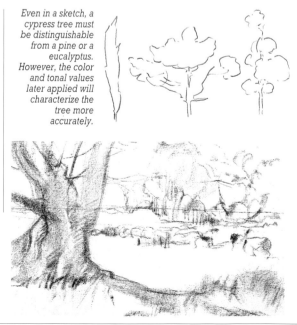

*For an oil painting, the sketch is initially drawn in charcoal with light lines on the canvas.*

### The Important Points

As you measure, you will realize that there are certain key points that must be located on the support. These points are different in each model and, in general, allow the blocks or sections of the sketch to be related. The first point that you establish should be easy to locate. The following points are defined by taking measurements along horizontal or vertical axes, in simple fractions of the key unit of measure that relates height and width, etc.

*Before making the sketch, study on a scrap of paper the important points and lines of the chosen frame.*

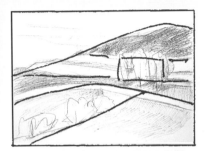

*The center of the paper and the medians are elements of reference. The general lines are placed through spatial relation. One point can be located halfway between two others, or a third of the way, as the case may be.*

## Blocking In

Once the format has been decided, the first lines of the sketch are drawn to block each element into simple geometric shapes. Everything can be blocked together or separately. The objective is to make the proportions between elements in the representation correspond to the real scene.

## The Sketch and the Medium

The sketch is usually drawn in such a way that it gradually becomes incorporated into the representation as it is covered by the chosen medium.

Sketches are usually done in pencil or charcoal. With pastels, it is best to use chalk.

For oil, charcoal or diluted oil paints are used, whereas for watercolor and other transparent media, a watercolor pencil is recommended.

**MORE ON THIS SUBJECT**

- Tonal values **p. 34**
- Drawing techniques **p. 36**
- The artistic sketch **p. 74**

## Measurements

An artist always measures distances by using the pencil or brush to be used later for drawing or painting. All measurements are taken horizontally or vertically, and always from the same position. Extend your arm holding the pencil or brush so that you can see the object to be measured. Use your thumb to mark the length of the object on the pencil or brush.

The total height and width of the frame are important. The relation between them gives us the format of canvas or paper to use.

Measurements are made until the relations between the most important elements are well established.

*Gray chalk is suggested in the preliminary sketch for an oil painting.*

# TONAL VALUES

When studying the color structure of the plant model, one must distinguish not only the different colors but also their tones. The idea is to assign distinct areas of colors and tones, separating them in your mind. This is a designation system. In applying it, shape and volume are obtained through color.

## The Model and Tonal Values

In any illuminated scene with vegetation, various colors and tonal values appear. The details are simplified by squinting. Major color and tonal areas can be set off. The light tones correspond to the illuminated part of the vegetation. As you reach areas less exposed to light, the tones become progressively darker. The darkest tones correspond to the areas in the shadows, the darkest tones in the model.

Some artists already divide the support into areas of tonal values when they execute the sketch. They create a tonal sketch. The lines setting off the color and tonal areas are an aid to structuring color in a representation.

## From the Model to the Representation

Once the color and tonal areas have been located in a model with vegetation, the artist attempts to transfer them onto the representation. The palette work, therefore, consists of creating all the colors and tones involved through mixtures. Each medium has a specific procedure for "mixing."

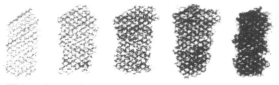

*With black and white drawing media, as is the case with graphite, tonal values can be created and organized according to their intensity. The greater the pressure applied, the darker the tone.*

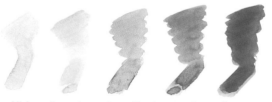

*With media that allow monochrome work, such as Conté pencil, the tonal value is created on the basis of that color. The harder the pencil is pressed against the paper, the darker the tone.*

**Full color media allow the creation of tonal values from any manufactured color or mixture, in a transparent or opaque manner:**

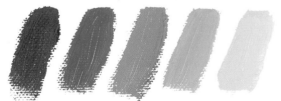

*Mixing yellow ochre and vermilion in watercolor produces an orange color from which various tones can be obtained through washes in combination with the white of the paper. The more water added, the lighter the tone.*

*With the acrylic colors cobalt-chrome blue and ultramarine, a blue mixture is obtained. When white is progressively added to this mixture, lighter and lighter tonal values can be created with opaque paint.*

**MORE ON THIS SUBJECT**

• The preliminary sketch **p. 32**
• Drawing techniques **p. 36**

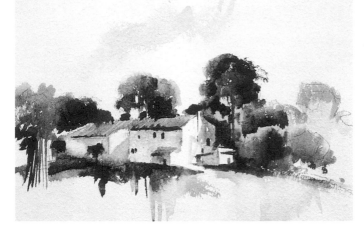

*Volume and depth gain expression through a tonal roughing-out in watercolor based on two colors: sepia and Payne's gray.*

## Mixtures in Each Medium

The desired mixed color is always made from the manufactured color that most resembles it, with the addition of one or more colors to change the hue. The procedure depends on the characteristics of each medium.

## Light Tones in Each Medium

In each medium and each technique, there is an ideal way to achieve light tones. Opaque media, such as oil, acrylic, and gouache, require white to create light tones. But with watercolor, which is transparent, light tones are created by diluting a color with water and using the white of the paper to brighten it.

### Dark Tones

There are certain colors and color mixtures that can be used for darkening other colors. These are the darkest and most intense colors of the palette. Deep madder lake, burnt sienna, burnt umber, and Van Dyck brown are the warm colors that are primarily used to darken other warm colors. To create darker tones in cool colors, deep blues (such as ultramarine and Prussian) and emerald green are very effective. Combined with sky blue or cobalt, or light green, shadows acquire great luminosity.

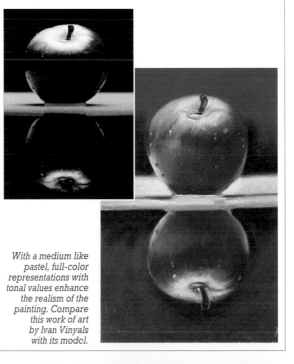

*With a medium like pastel, full-color representations with tonal values enhance the realism of the painting. Compare this work of art by Ivan Vinyals with its model.*

# DRAWING TECHNIQUES

Drawing techniques are based on the principle of the line. Whether through dots or lines, regular or irregular patterns ensure the creation of mixtures and tones. With juxtaposed strokes covering the surface of the support without apparent breaks and darker areas, shading and colored areas are created with a more homogeneous appearance.

## The Line

Charcoal, graphite pencils, and Conté pencils are applied in linear strokes. Their intensity, thickness, and direction are controlled by the pressure applied to the stick or pencil. Practice enables the artist to describe the profiles of elements to be represented. Strokes can be straight, curved, or mixed. For best control, the instrument must be held firmly. For detail work, the fingers are placed near the drawing tip of the instrument. For longer lines, the stick or pencil is normally held at a point farther away from the drawing tip.

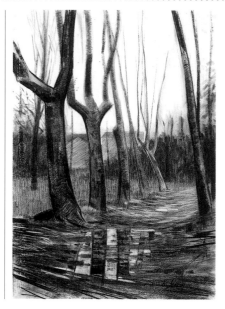

*Charcoal and Conté are perfect media for beginners. In this landscape with bare trees, both media were used together.*

*Shading created by cross-hatching patterns can alternate with artistic strokes expressing synthesis.*

*In shading without perceptible strokes, gradations have a greater value and move from one tone to another without breaks.*

## Cross-hatching

Cross-hatching or dotted patterns can be regular or irregular and are carried out with dots or lines. These patterns allow the creation of tonal values. The denser and more intense the dots or lines, the darker the tone achieved. If these tones are applied in a progressive manner, a tonal range is produced.

The different tonal values placed alongside one another with no tonal jumps result in optical gradations.

Ink applied exclusively through the use of a nib is primarily based on strokes and patterns. Although it is a wet medium, it is traditionally considered a drawing medium.

**MORE ON THIS SUBJECT**
- The preliminary sketch **p. 32**
- Tonal values **p. 34**

## Shading or Colored Areas

Shading or colored areas may show no perceptible strokes. To achieve such an effect, the artist must practice making consecutive strokes very close to one another and covering the surface of the support without leaving blank spaces.

Graphite pencils and colored pencils are two media that can be used to cover large spaces quickly. The shading done in graphite pencil and the colored areas created with colored pencils can be subdivided into small areas. You can begin with one small area and shade or color it in, and then go on to the next one, and so on. Practice allows the artist to blend the transition areas.

### On Drawing

When creating outlines, the direction of the stroke follows the object, but when shading or coloring, whether the stroke is visible or imperceptible, there is one appropriate direction for the lines. The objective is to describe the volume of an element of vegetation. To do this, the lines should correspond to the sections that would be produced if this element were to be cut along horizontal and vertical planes according to the appropriate perspective.

The drawing media are always closely related to other media. In media that use brushstrokes or the palette knife, the direction in which these are applied must be in accordance with the drawing.

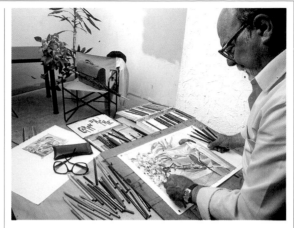

*You should make yourself comfortable to facilitate your work. When drawing, it is essential to maintain the support with the paper in a fixed position so that you can draw with assurance.*

## Gradation

When several tonal values are drawn in juxtaposition and without breaks in tone, it is called a gradation. Drawing media such as charcoal, graphite pencil, colored pencil, and Conté pencils allow gradations to be achieved immediately with imperceptible strokes through shading and colored areas. If perceptible strokes are used for a tonal range, a more gradated effect can be achieved through the techniques of blending, also called stumping.

Charcoal, Conté, and chalk are dry media through which blending becomes richer and more sensous.

*A full-color medium such as colored pencils requires a great deal of practice in filling areas with color and in superimposing layers of color. The drawing techniques used are tonal and based on blending.*

# THE DRY MEDIA

This category includes several media: charcoal, Conté pencil, chalk, and pastels. These media can be applied directly and contain no moisture or greasy material. Their most important features are that they are direct, easy to remove, and are especially well suited for blending and spreading.

### Any Part Will Do

Any part of the charcoal, Conté pencils, chalks, or pencils can be used to shade or color in areas. In the case of charcoal and pastels, the product usually comes with a protective aluminum or waxed paper strip around it. Completely or partially remove the strip and use the unprotected surface. With charcoal, Conté, or pastel pencils, only the visible part of the lead can be used to apply color.

### Charcoal

Charcoal is sold in cylindrical sticks. Because it is fragile, charcoal requires a certain amount of practice to handle, especially with regard to very

*Pastel is a direct drawing-painting medium.*

vigorous strokes. The high friability particular to charcoal limits its use mostly to studies

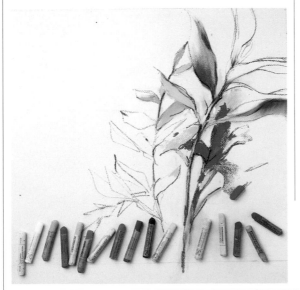

or sketches. This also makes it an ideal medium for preliminary sketches to be developed later in other media. It is also sold in the form of lead for pencils and as pencils called Conté.

### Conté

Conté comes in the form of a rectangular stick, a crayon, or a pencil. It is the most permanent of all the dry media. It is traditionally used for preliminary studies. Like charcoal, it allows drawings that develop tonal values.

The stick of Conté is less fragile, less removable, and

*Pastel requires an ample selection of colors to achieve spectacular results.*

*Any part of the stick of pastel can be used to make lines and color in areas.*

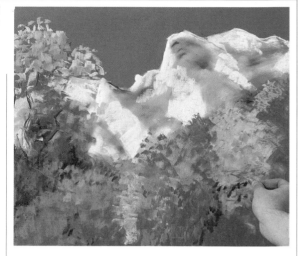

## Gradation with Dry Media

Shading or color can be applied without apparent strokes. In addition, in any dry media, you can observe the high quality of the gradation. Without tonal jumps, these gradations express volume realistically. The pictorial quality of gradations is evident when they are subject to blending. The blended shading or colored area looks different from the untouched application. The effect of blending, when used in moderation, offers a final work with lots of tones and hues.

Mixtures must be produced through the traditional operations of this media, such as gradation, superimposing layers, and blending. The best work is done on the basis of a wide range of colors. In this way, a mixture can work with the slight addition of another color.

## Blending

Blending is understood as the capacity of all dry media to be extended on a support with the use of a cotton cloth over a layer of charcoal or color.

You can also use a stump, a paper, a brush, a finger, or any other part of your hand.

| MORE ON THIS SUBJECT |
| :--- |
| • The preliminary sketch **p. 32** |
| • Tonal values **p. 34** |

harder than charcoal, and is usually applied in strokes.

## Chalk and Pastels

The softer the pastel, the more fragile it is. Soft, highly fragile pastels are nearly pure pigment with hardly any gum arabic. Semi-soft pastels provide somewhat less color but are stronger than the soft ones. Hard pastels contain less pigment and thus stain the paper less.

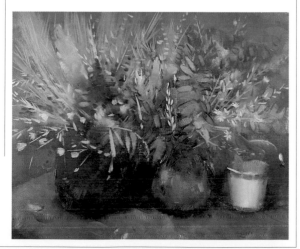

*Pastel is a medium that allows a maximum degree of realism, as in this work by Francesc Crespo.*

# OIL

The oil medium, especially in its tube presentation, is traditionally the favorite of the majority of artists. To work in oil, you basically need a paintbrush or palette knife, a palette, and a thinner. Mixtures are usually done first on the palette, and the paint is applied in layers on the canvas.

## The Implements

You'll need several paintbrushes of different sizes. Each artist favors a particular type of tip, although with practice, any shape tip can be used to effect various kinds of brushstrokes. Wide brushes have a very wide tip with which to cover large areas. These are particularly useful for the first coat. A fan-shaped brush is

*It is essential to organize the colors on the palette. Warm colors must be placed together and arranged from light to dark. The same procedure is followed with cool colors. Both groups need to be kept separate.*

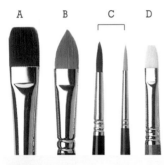

A     B     C     D

*The tip and the characteristics of the bristles on oil brushes vary in shape, such as:*

A. *Chisel-edged flat, with beveled edges*
B. *Filbert*
C. *Fine round*
D. *Flat*

### MORE ON THIS SUBJECT

- The preliminary sketch **p. 32**
- Tonal values **p. 34**
- The medium and its stages **p. 68**

usually used to apply transparent layers or to gently blend colors on the canvas.

The palette knife allows paint to be applied thickly. It is used to effect sgraffito on moist paint as well as to flatten it. The palette knife allows mixing without having to spend so much time cleaning up. Unlike the brush (which must be washed thoroughly with turpentine and then soap), the palette knife is cleaned by simply wiping it with a paper towel.

### Thinner

There are several products that can be used to dilute oil paint. A mixture of linseed oil and pure turpentine is the most common. But there are other oils, such as poppy or walnut, that increase the luminosity of transparent oil applications. Other products, such as Dutch varnish, can be incorporated into the paint as it is applied to provide a shiny finish. Finishing varnishes are applied only when the painting is complete.

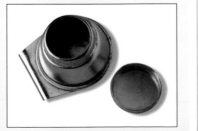

*The oil container is very useful. It can hold the thinner you need while you paint and can be clipped to the palette.*

*The palette knife and the paintbrush are the two primary implements for painting in oil.*

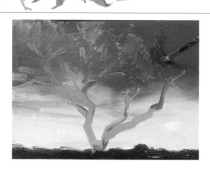

An oil painting is generally carried out in several stages. In the first stage, the basic color areas are applied.

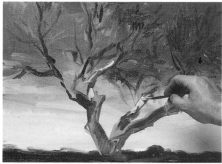

In the second stage, the addition of paint allows a progression toward greater definition of any plant motif. Here the subject is a tree.

## Mixtures in Oil

The palette is normally used for mixing oil, but it is also possible to mix directly on the canvas. It is a common practice to modify colors that are already applied by adding small amounts of a different color to brushstrokes. Mixing on the palette is based on an organized distribution of colors, ranging from warm to cool. With the palette knife or brush, portions of several colors are transferred to a clean area of the palette for mixing. The mixture is carried out by progressive approximation. If necessary, more color is added to the mixing area with the paintbrush or palette knife.

## Working in Stages

An oil painting is generally carried out in several sittings. During the first application of color, the paint is thoroughly thinned. The thinner is made of approximately 40% turpentine and 60% linseed oil.

The second stage can begin once the first layer of paint has acquired some consistency, that is, when the paint no longer leaves a stain when you rub your fingers across it. At this point, the second layer of paint will not mix with the first. Less thinner is used in the second stage.

Finishing touches and adjustments are usually added at the end. The paint is applied in all of its density. This is when highlights and reflections are added.

## Drying Time

Oil dries slowly. Depending on the colors and thickness of the layer applied, drying time can take anywhere from 24 hours to several days. For a somewhat quicker drying time, the turpentine component of the thinner can be increased up to 50%. Oil will dry very quickly if small amounts of cobalt drying agent are added to the paint. However, the drying agent clouds the colors and if used in profusion, will cause the painting to crack.

The brushwork is often richer if applied after the underpainting has acquired consistency.

The technique of gradation is often used to render backgrounds. Oil can be applied in transparent and opaque layers in the same work.

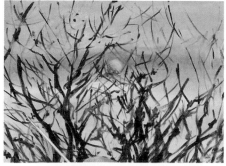

# THE VERSATILITY OF ACRYLICS

Acrylic is a contemporary medium. It is manufactured of artificial components and polymerized by drying. Acrylic is a fast-drying, highly versatile medium. It can be applied to produce very flat effects, or just the opposite, to create depth as if it were oil, by the addition of thinning or thickening agents. The quality of its transparencies when thickening gel is added is unique.

*Acrylic is a quick-drying medium.*

*A painting can be completed in a single session.*

## How to Work in Acrylics

Acrylic, as it comes out of the tube or from plastic containers, can be applied directly onto paper or canvas, but its effect is absolutely flat. If you want it to run more freely on the support and allow other effects, an agent or acrylic gel must be added. These products, with matte or shiny finish, allow the paint to be thinned for opaque or transparent use. When transparent gel is added, an effect is achieved which is impossible to duplicate in oil; that is, a thick layer of highly transparent paint with which to create a thick transparency.

## Preparation of Acrylics

To each mixture, the most appropriate acrylic agent or gel must be added. The colors are arranged on the palette, but a space should be reserved for the agent used, which can be kept in a glass or other container. In addition to the paint and the agent, you should also have a container for water.

### Many Supports

Acrylic can be applied on any type of support except one with a greasy surface. Many types of paper can be used as long as they have sufficient thickness to hold the moisture and the paint itself. Acrylic can be used on cardboard or wood panels. Canvas mounted on a stretcher is prepared by priming it with an acrylic product.

*Acrylic can be applied on paper.*

*It can also be used on canvas.*

A dirty paintbrush can be cleaned easily if the paint is still moist. Just dip it in water and stir. Once the paint has dried, however, the brush is ruined. The tip becomes a hardened compact mass that has lost most of its elasticity.

## Color Mixtures

Acrylics can be mixed on a separate palette. This paint dries rapidly and cannot be

*Acrylic paint can be applied by air brush. The effect achieved by Miguel Ferrón with this process can be spectacular hyperrealism.*

removed, so in order to keep your palette clean, use a porcelain or glass plate. The paint can easily be removed with water when it is still moist. Once it dries, soak it in water and after several hours, the paint will come off as a compact film. Just as in oil, mixtures are made by successive approximation, setting aside small quantities of the colors to be mixed. In general, the color used in greater amount is placed in the mixing area first, and then the color that will modify it is added a little at a time.

**MORE ON THIS SUBJECT**
- The preliminary sketch **p. 32**
- Tonal values **p. 34**

## Characteristics of Acrylic

In addition to drying very rapidly, once polymerized, it becomes highly resistant to light and water. Because the quickness of drying can be a detriment, there are products on the market that retard drying. These agents are added in small amounts to the paint before applying it to the support.

Once dry, acrylic is a very durable paint. This makes it preferable to watercolors for some works, although it does not have the same spectacular effects or luminosity. It can also be used to replace gouache (very common when attempting to produce flat paintings), since gouache cannot be applied thickly without cracking.

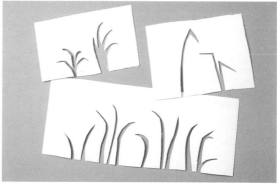

*Acrylics lend themselves to use with stencils. To represent grass, for example, different blade motifs can be cut out of cardboard. Mixtures created from cool colors—blues and greens—are then applied, superimposing stencil patterns in a varied manner.*

# WATERCOLORS

Watercolor is unquestionably a spectacular medium because of its luminosity. It requires good control of the water component. The difficulty in execution requires many hours of practice, tenacity, and a stubborn will to succeed. The paintbrush and water play the leading role, although certain effects depend both on technique and a variety of tools.

## The Presentation

Watercolor comes in dry cakes, in pasty consistency in tubes, and in liquid form in jars. The most commonly used forms are the dry cakes and the tubes for practical reasons. When vegetation is painted outdoors, watercolor in pans is very convenient. In general, works are not done in large format, and the amount of diluted color necessary fits into small containers or on the palette. The tubes provide the greatest quantity of a diluted color. In the final analysis, it is the artist who decides what form of watercolor presentation to use for greatest convenience in mixing and handling.

## The Transparency of the Medium

Watercolors strongly diluted in water allow the application of color in very fine, highly luminous layers. Watercolors that are less diluted with water, especially of the tube variety, become almost as opaque as gouache and lose a great deal of their appeal. Watercolors are mainly used for their transparent qualities.

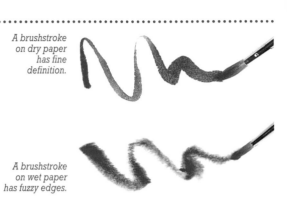

*A brushstroke on dry paper has fine definition.*

*A brushstroke on wet paper has fuzzy edges.*

This requires the sequence of color applications to be established before starting.

## Water

Two water containers are convenient to have at hand—one for clean water to moisten the paper or to add to the paint or to mixtures, and the other for cleaning the brushes. The water in both containers should be changed as it gets dirty.

## Wet on Dry

Diluted watercolor can be applied on dry paper. In this case, the brushstroke or color area will have a defined edge. It can also be applied on another layer of paint that is already dry. This superimposition is a way of achieving different tones of a single color or of mixing colors directly on the paper without the use of the palette or container.

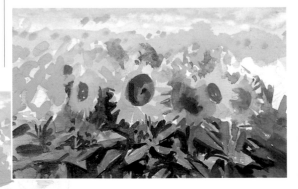

*The first application of color must be the most luminous.*

When the paint dries,
tonal jumps can appear in
watercolor paintings.

Keeping some areas white,
using homogeneous
applications, gradations, and
painting on wet or dry paper are
processes that are used at
different times throughout the
process of creating a painting.

## Wet on Wet

Watercolors can also be applied on paper previously moistened with water. In this case, the outlines of the brushstroke or color area will have fuzzy edges.

Applying a color on another color that is still quite wet allows the creation of what is called a variegated wash. These have great visual impact and are one of the greatest virtues of watercolors.

### Homogeneous Application

It is difficult to apply an area of color in watercolors in a homogeneous manner. With gouache the effect is immediate. With watercolors, the paper may be moistened slightly beforehand. Color is then distributed homogeneously over the wet surface. When working on dry paper, enough diluted color must be prepared so that the artist can progress quickly. Complete and enlarge the color area, always extending it on the wetter side.

| MORE ON THIS SUBJECT |
|---|
| • The medium and its stages **p. 68** |
| • Watercolor and its techniques **p. 72** |

## Gradations

Watercolors allow the creation of delicate gradations in an immediate manner. Paint using a brush with a lot of pigment but little water. Immediately take more water with the brush and add it to the first brushstroke to extend it. Pressure is hardly applied, and the operation is done in a single brushstroke.

## Mixtures by Superimposition

The secret of mixtures by superimposition is always to apply the lighter color layer below the darker one. The first layer must dry completely before the application of the second. The second layer requires the brush with the second well diluted color to be applied lightly so as not to drag any particles of the first layer.

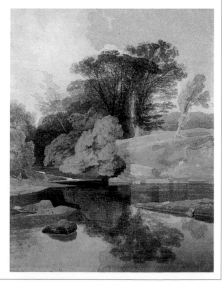

John Sell
Cotman.
Dark Pond.
National
Gallery of
Scotland,
Edinburgh.
The color
planes
construct the
landscape.

# GOUACHE

Gouache differs from transparent watercolor basically because of its opaque finish. This medium has a high proportion of pigment which quickly colors the support and is diluted in water. Gouache can be used to create flat effects, although it is also useful to create mixes by frottage with a brush or mottling with a palette knife.

## Always Fine Layers

One of the drawbacks of gouache is that it does not lend itself to application in thick layers, since when it dries, it tends to crack. The paint simply comes off in chunks. Many artists have switched to acrylic to achieve the same objectives. For advertising motifs in graphic arts, acrylic offers more versatility and, above all, more durability than gouache.

## Presentation and Use

Gouache comes in tubes or in glass or plastic jars. For practical reasons of space, tubes are the most practical for field work, while the jars are normally used for large format works done in a studio.

Gouache paint has a thick consistency directly out of the tube or jar. It could be applied directly to the support, but to avoid cracking and achieve progressively more homogeneous layers of texture, water is constantly added to gouache. It

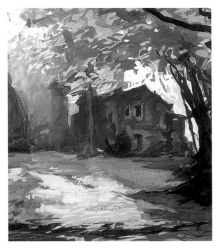

*Gouache can be used as a non-flat medium with expression of depth. Work by Miguel Ferrón.*

### MORE ON THIS SUBJECT
- The preliminary sketch **p. 32**
- Tonal values **p. 34**

is essential to have two jars for water. One contains clean water for diluting or mixing, and the other for cleaning the brush whenever necessary.

### A Flat Paint

It takes practice to achieve gouache's flat effects. To apply the paint so that it is homogeneous in color and texture, it must have the optimal degree of dilution with water. The brush itself must be carefully selected. The more malleable the tip and the finer the hair, the easier it is to achieve a completely flat effect. The paint is spread in one direction, which is usually from top to bottom or from left to right (for right-handers).

*Here, gouache is applied as a flat medium with no superimposition of colors.*

*Gouache is so opaque that it can be applied in light on dark layers. Here, the snow-covered tree was painted on the blue background.*

## A Burst of Color

Gouache provides a brilliance of colors impossible to achieve in other media, including acrylic. Using the colors directly and applying other techniques, this richness can be used to create either a flat painting or one with depth. In the latter case, the brushstrokes are done so as to produce optical mixtures that show different color values and tones.

## Gouache and Professionals

Although gouache is generally applied with a paintbrush, any other tool will do as well, even your finger. For this reason, gouache and tempera are often used in schools. When used by a professional, gouache can rise to levels of true virtuosity.

## The Opacity of Gouache

Gouache, as an opaque medium, allows a dark color to be covered by another layer of color, even if it is lighter.

Gouache can be applied light on dark or dark on light. Nonetheless, it is best to apply colors such that they remain within the desired areas to avoid having to go back later and cover the mistakes, losing part of the brilliance of the colors.

Gouache can be used with a great deal of water. But the layers are not as transparent as watercolor when it is properly applied. Gouache can produce a semi-opacity, a process used to avoid a flat effect.

*Gouache has a medium drying time. This enables the artist to apply color progressively, superimposing layers rapidly until the desired texture is achieved.*

# INK

Works done in ink can have many different aspects, since in addition to the personal interpretation of the artist, there is also the stroke of the implement used, whether it be a brush, reed pen, or fountain pen. Ink is an old medium that was originally available in black or sepia, but presently comes in a wide range of colors.

## Indelible Ink

India ink is known for its indelibility, that is, once it has dried, it cannot be removed, unless physically scraped off the surface of the paper.

Only tiny spots that are still wet can be minimized. Quickly add clean water and dry it immediately with blotting paper.

The difficulty of working with ink lies precisely in the fact that it is indelible. It is not possible to make corrections, as they can be easily seen.

A quick and confident hand is essential.

*In addition to black India ink, many other colors are available.*

## Brush, Reed Pen, or Fountain Pen

These implements leave very different traces on the paper. Fountain or reed pens are more appropriate for drawing techniques, such as shading by cross hatching, and artistic gestures are emphasized. The use of brushes usually involves the application of washes, either homogeneous or gradated. With any of these imple- ments, water can be used as a diluting agent, but it is most frequently used with a brush to create a wash.

## Many Techniques

Black ink from the jar can be used with a brush or reed pen. When the ink is diluted with water, tones can be created.

This is a type of drawing with possibilities for creating

*Strokes made by a reed pen on paper are very individual and very artistic.*

*Ink, once dry, is indelible. Colors can be applied over one another without their mixing.*

*On non-grain, satin-finish drawing paper, texture is created wholly with the implement. On a paper with grain, texture is enhanced by the relief.*

tonal values other than cross-hatching.

With ink it is possible to alternate tonal techniques in a single work, with or without cross-hatching. The great pictorial richness of this medium is one of the features that makes it most attractive, compensating for the difficulties of its indelibility.

### The Artistic Aspect

Each type of ink has a unique finish, although the final results depend as well on the characteristics of the support used. When more ink is applied, the effect is shiny, with very fine and definite, concrete contours. Therein lies the great descriptive strength of works done in ink. This finish, along with the great durability of the media, makes it appropriate for lithography or silk-screening.

*Van Gogh. Lead Mines. Pen technique. In this work, shading is done using different line patterns and directions that are very descriptive of each element. The different grounds are easily distinguishable.*

| MORE ON THIS SUBJECT |
| --- |
| • The preliminary sketch **p. 32** |

### Scratching

Small errors and drips can be removed by scratching. This is an aggressive procedure, because it removes not only the ink but also particles of the surface of the paper. A razor blade or an Exacto will do for this process. Special care must be taken not to perforate the paper by pressing too hard. Scratching should always be done gently and progressively until the desired results are achieved.

When the subject is an element of vegetation, it is not always necessary to remove the entire area of a mistake by scratching. It is also possible to alter the drawing, as long as it looks plausible, and therefore scratch out only a small portion of the mistake.

### Qualities of the Colors

Ink colors are bright and strong. With their very clean finish, colored inks are a good medium for both drawing and painting. Mixtures can be made in a glass or other container and are done according to color theory just like in other media. Black ink is certainly inappropriate for darkening colors. When used for mixing, it blackens colors instead of simply making them darker.

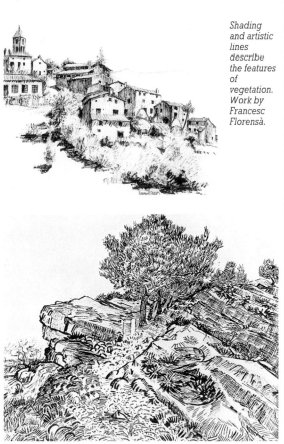

*Shading and artistic lines describe the features of vegetation. Work by Francesc Florensà.*

# VEGETATION: DRAWING AND COLOR

Any element of vegetation has its own lines and color. With regard to its lines, the essence is established through an analysis of the total picture. Only the essential features are of interest. Regarding the color (which depends on the characteristics of the light cast on it), the tonal values that will allow volume to be expressed must be determined. The techniques appropriate to each medium must be used.

## Sketches

Sketching is highly recommended. On small sheets of paper, the most important features of the shape and color of the element of vegetation in question should be sketched in graphite pencil or even in marker. Sketches with tonal values facilitate resolution later, even in the structure of the color. These sketches should be quick and synthetic, that is, they must contain all of the information indispensable for a subsequent finished drawing.

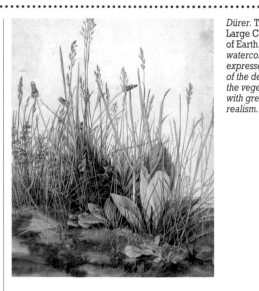

*Dürer.* The Large Clump of Earth. *This watercolor expresses all of the details of the vegetation with great realism.*

### MORE ON THIS SUBJECT
- Light **p. 20**
- The palette **p. 26**

## Drawing, Line, and Brushstrokes

Drawing, even without details, is generally carried out with the implements that are easily adapted to the medium.

*The drawing can be done directly by reserving white areas and later applying watercolors.*

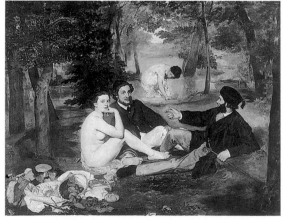

*Édouard Manet.* Luncheon on the Grass. *The color of the vegetation is treated with less definition than that given to the figures.*

*The purpose of applying brush-strokes (through their direction or intensity) allows form to be modeled.*

## Volume Through Tone or Color

With black media (such as charcoal or India ink) or mono-chromatic media (such as using a single color of Conté), the volume of the element of vegetation can only be represented by differing tonal values.

Full color media, such as colored pencils, pastels, oil, watercolor, acrylic, gouache, markers, and colored inks allow volume to be depicted through color as well as tone.

When the color structure of the element of vegetation is analyzed, the respective tonal areas of each color involved must be located.

Both line and brushstroke are used to describe the shape and even the contours of volume, thanks to the flowing lines.

The intensity, thickness and direction are very descriptive features of a line or brushstroke. The artistic value of the brushstroke or line lies precisely in the spontaneity of the gesture. The success of the contours describing the element of vegetation, with flowing lines and alternating intensities and directions requires a great deal of training.

The medium determines the size of a work. An oil painting can be done in large format, whereas a watercolor painting or a work done in pencil or ink normally takes a smaller or, at most, medium-sized support. Lines or brushstrokes produced on small areas or sweeping over larger areas involve very different execution.

### Appropriate Color and Tone

Colors and their tonal values describe the drawings in and of themselves. A sketch of the lines of the subject is used as a base on which to begin to apply tones, or colors in their corresponding tones.

Inappropriate application of tones or colors alters not only the drawing, but also the expression of volume.

Every time you are about to apply a stroke or create a color area, you must consider its appropriateness within the context of the other strokes and with the same objective in mind: faithfulness to the artist's interpretation.

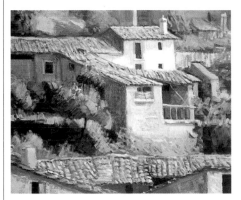

*Tonal and color work of Joan Sabater allow the volume of each plant to be depicted.*

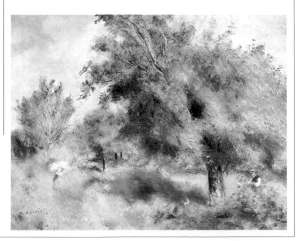

*Pierre-Auguste Renoir, 1885. The British Pear Grove. Oil on canvas (detail). Colors are blended directly on the canvas, modeling the volume of the details in the vegetation.*

# VEGETATION: TEXTURE AND RHYTHM

What allows the representation of an element of vegetation is its drawing and the application of the appropriate colors and tones. It is also carried out through texture, and the artist's mastery creates a pictorial rhythm.

## Sequence of Procedures

Regardless of the medium, the technique used creates special effects. When techniques are mixed, highly diverse effects can be created. Each model of vegetation and the analysis of its surface and location with regard to the foreground, middle ground and background call for the most appropriate sequence of techniques.

Hence, painting is not only a matter of drawing, color, and tone, but also of texture. The value of texture as a vehicle for dramatizing and expressing forms and colors is inherent.

## Material Painting

In media that allow impasto and other thick materials, such as oil or acrylic, texture can attain great relevance. Texture

can be used to reproduce reality as faithfully as possible. The field of plastic arts is undergoing a revolution with the creation of light effects that are perceived as coming directly from the painting. Under correct lighting, all relief on the surface of a painting increases the color contrasts in optical mixes by the law of simultaneous contrast.

The texture of academic painting, once considered the model of technical perfection,

*It is impossible to represent all the details of vegetation. The features of a meadow, for example, must be represented in synthesis.*

### The Imitation of Surfaces

In highly realistic representations of vegetation, especially those done in the immediate foreground, the right sequence of techniques allows the achievement of absolutely photographic effects. There is presently a realist or even hyper-realistic movement. There is also a chromatic avant-garde movement.

sought tonal modeling of elements of vegetation, and produced absolutely smooth surfaces. Beginning with Impressionism, the canvas began to be painted with decision and force in the impasto. Post-impressionism, Fauvism, etc., and the more recent Informalism are all links in the progression toward abstraction. New values have been introduced in texture, subject matter, concept, and technique.

*Vincent van Gogh.* Wheat Field and Cypress Trees. *Oil on canvas. It is interesting to observe the different textures given to each element of vegetation to differentiate them.*

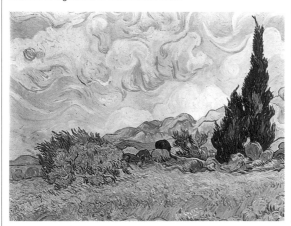

**MORE ON THIS SUBJECT**

· Vegetation: drawing and color
**p. 50**

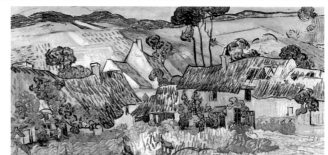

*Vincent van Gogh. Farmhouses Near Antwerp. 1890. Oil on canvas. Tate Gallery, London.*

*The different textures created to describe each element in this landscape (the vegetation and buildings) develop a rhythm.*

## Lines or Strokes for Texture

To create a texture, not only the type of lines or strokes must be considered, but also when they are applied and using what technique. There is a sequence of procedures for each type of texture. The alternation of techniques, superimposition of layers, and the characteristics of these layers, allow specific textures to be achieved.

In each medium, several types of texture can be created. The texture most appropriate for a background must be differentiated from that of an element of vegetation that is to be the center of interest. The level of contrast and the definition of form and color are crucial.

## Rhythm

When a model including vegetation is studied, the repetition of lines and forms, and even the distribution of colors and their application, produce a visual rhythm. At times, it is the artist who interprets the subject with an emphasis on rhythm. In general, rhythm is associated with the dramatization of light or form. The essence of rhythm becomes very evident in genre or "snapshot" renderings of landscapes by the impressionists, post-impressionists and expressionists, who were drawn to subjects with vegetation.

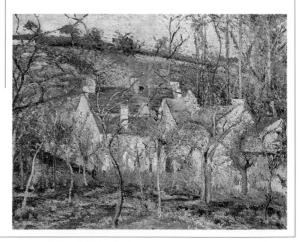

*Camille Pissarro. Red Rooftops. Oil on canvas. The artist seeks the real color through tonal values, creating points of light with pure colors. The rhythm depends on the techniques used and is the artist's personal expression.*

# SUPPORTS FOR DRY MEDIA

Any surface will serve as a support for dry media, as long as it provides good adherence capacity for the medium when applied. Paper, cardboard, panels of all sorts, and even fabrics can be suitable as long as the applications are durable.

## Dry Media

All media that is applied without the abundant use of any moisturizing agent, such as water, oil or alcohol, are considered dry. Charcoal, Conté pencils, chalk, and pastels are considered dry. Graphite pencils, colored pencils, and wax crayons, although greasy, also allow dry use, since the greasy or waxy content of the media is not considered wet.

### MORE ON THIS SUBJECT
· Basic drawing materials **p. 58**
· Accessory materials **p. 62**
· Preservation **p. 64**

*Paper specially manufactured for use with pastel comes in a wide range of colors and can also be used for pencil, charcoal, and Conté.*

## Paper

There are specific types of paper for every media. The most important characteristics of paper are its thickness, composition, rigidity, and texture. Lightweight paper for sketches is available, as well as paper with more body for definitive drawings. There are papers especially designed for chalk and pastels that come in a wide range of colors. Paper for watercolor is normally

*Paper is the most commonly used support for dry media. Its color and texture influence the final results.*

heavy and can also be used for dry media. Even the relief, whether it be medium or thick grain, can enrich texture.

The rigidity and weight of paper are very important for works done in curved lines and require a certain degree of vigor in execution. It is not a good idea to create definitive works on paper that wrinkles easily.

## Cardboard and Posterboard

Cardboard and poster-board have sufficient firmness to avoid wrinkling with the use of dry media. Nonetheless, they do not always provide the most suitable surface for all dry media (charcoal, Conté,

*Although paper is the most common support, you can also use cardboard, posterboard, wood, or fabric.*

chalk, and pastels) nor the greasy media for direct use (graphite pencil, colored pencils, and wax crayons). As a general rule, surfaces should not be satiny.

### Rigid Backing

With the exception of canvas mounted on a stretcher, all supports that are not very rigid, such as paper or cardboard, require the use of rigid backing for drawing or painting. The backing should be 5–6 cm larger than the format of the work. This allows the support to be attached to the backing so that it will not get dirty. To avoid undesired wrinkles or folds in the paper, cardboard, or posterboard, the four corners of the support must be attached with clips or tacks, which will not perforate the support.

*Paper, cardboard, and fabric—unlike wood—require a rigid backing for convenience. The backing, which can be wood, plywood, pressboard, etc., must be somewhat larger than the work itself.*

## Wood and Other Panels

Although these are not common supports, many artists use wood panels, pressboard, or plywood as a drawing support. Non-varnished surfaces are often appropriate for use with dry media.

The color of the panel constitutes a base color which must be taken into account when picking the color of vegetation or any other motif.

These surfaces can also be primed with white acrylic paint or latex so that tones can be achieved through transparency. This would be the equivalent of painting on white paper.

## Other Supports

Although canvas is a support more closely associated with wet media, it can also be used for dry media. The white primer of a canvas prepared for oil or acrylic has very interesting effects when used for drawing or painting with pastels or colored chalk, or even wax crayons.

# SUPPORTS FOR WET MEDIA

Supports for wet media must be able to absorb the right amount of moisture
in each medium. Ink, watercolor, gouache, and acrylic are water-based. Oil paint,
as a greasy medium, requires a support capable of absorbing the oil it contains.
An inadequate support will result in a halo effect.

## Paper

Ink, watercolor, gouache, and even acrylic are commonly applied to paper. The wetter these media are, the thicker the paper should be. Paper that absorbs little moisture is usually thin and warps permanently. Special paper for ink is available and similar to parchment. Other types of paper such as Mayor or Geler, designed for technical drafting, can be used for ink, watercolor, wash, gouache, and acrylic.

Drawing paper such as Basik are especially appropriate for pencil and crayon, but can also be used for charcoal, Conté pencil, chalk, and pastels, and even as a support for direct application of ink.

Watercolor paper can be used as well for markers, gouache, and tempera.

Ingres or Mi-Teintes type paper, especially designed for dry media, accepts watercolor with very little water. They also take gouache with little body and low moisture.

There are certain types of paper specially manufactured for oil, such as Figueras, that

*Watercolor paper is suitable for use with media that is diluted with water. Satiny paper will cause ink applied with a nib to run.*

*Canvas is the most common support for oil. It is usually mounted on a stretcher.*

imitates the weave of canvas. Others have a special primer that holds the oil.

## Canvas

Canvas is the most commonly used support for oil or acrylic, but can also be used for watercolor and gouache. It is available by the foot and can be stretched on a frame. Standard sizes are available in three format groups: figure, landscape, and seascape. The

*Stretchers are available in three formats for each size number. The height remains the same for each size while the width changes according to the format.*

canvas is already primed, that is, a primer is applied that is specifically adapted to the medium intended. These primers are optimal for oil and its slow drying process, or for acrylic and its quick drying process.

## The Quality of the Canvas

Canvas comes in different degrees of quality, generally depending on its composition, thickness of the thread, and

*A canvas mounted on a stretcher can be used vertically or horizontally.*

type of weave. There is a significant price difference between cotton canvas, cotton

### Stretchers

Stretcher formats are based on universal sizes. They are grouped under three categories according to the genre: figure, landscape, and seascape. The reason for this lies in the fact that these formats are traditionally associated with those needed for painting a figure, landscape, or seascape. Nevertheless, a seascape can be painted on landscape format and vice-versa, or a lying figure on a seascape format.

*There is an international table of stretcher sizes used to mount the canvas that has been primed for use with either oil or acrylic.*

and linen mixture, and linen canvas. The cheapest canvas should be used by beginners.

| INTERNATIONAL STRETCHER SIZES | | | |
|---|---|---|---|
| No. | FIGURE | LANDSCAPE | SEASCAPE |
| 1 | 22/16 | 22 × 14 | 22 × 12 |
| 2 | 22/19 | 24 × 16 | 24 × 14 |
| 3 | 27/22 | 27 × 19 | 27 × 16 |
| 4 | 33/24 | 33 × 22 | 33 × 19 |
| 5 | 35/27 | 35 × 24 | 35 × 22 |
| 6 | 41/33 | 41 × 27 | 41 × 24 |
| 8 | 46/38 | 46 × 33 | 46 × 27 |
| 10 | 55/46 | 55 × 38 | 55 × 33 |
| 12 | 61/50 | 61 × 46 | 61 × 38 |
| 15 | 65/54 | 65 × 50 | 65 × 46 |
| 20 | 73/60 | 73 × 54 | 73 × 50 |
| 25 | 81/65 | 81 × 60 | 81 × 54 |
| 30 | 92/73 | 92 × 65 | 92 × 60 |
| 40 | 100/81 | 100 × 73 | 100 × 65 |
| 50 | 116/89 | 116 × 81 | 116 × 73 |
| 60 | 130/97 | 130 × 89 | 130 × 81 |
| 80 | 146/114 | 146 × 97 | 146 × 90 |
| 100 | 162/130 | 162 × 114 | 162 × 97 |
| 120 | 195/130 | 195 × 114 | 195 × 97 |

## The Texture of the Canvas

The texture of the canvas does not depend on its quality. All canvases have a weave, but, depending on the number of threads per strand and the caliber of the thread, the weave can become very visible and have a thick texture, or it can be quite smooth and show no relief.

Every artist should become accustomed to the possibilities offered by each texture. An academic work with many glazes calls for a very smooth canvas, whereas an impasto painting makes better use of thick texture relief to achieve a more immediate richness.

**MORE ON THIS SUBJECT**
· Specific materials **p. 60**
· Accessory materials **p. 62**
· Preservation **p. 64**

*Acrylic paint can be applied on many surfaces.*

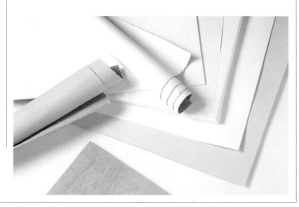

# BASIC DRAWING MATERIALS

No matter what medium you work with, it is always advisable to have basic drawing materials on hand for quick sketches; for example, paper in a folder or a small drawing pad. Other drawing tools can be placed neatly in a small box.

When working with ink, you will obviously need a mounted nib, a reed pen, and a brush.

## Drawing Materials

Although you may be working with watercolor, oil, or some other medium, it is always advisable to have a variety of drawing materials on hand. Essential supplies for carrying out quick sketches should also be readily available. Simple sketch paper is the most economical and the most suitable. A soft-lead graphite pencil or Conté pencil will suffice for quick sketch-es, and even for adding tonal values. It is also a good idea to have a soft eraser to correct errors. If your chosen medium is charcoal, even wrapping paper can be used; that is, its non-satiny side. With this medium, it is important to have clean cotton cloths and a spray fixative.

## Materials for the Preliminary Sketch

As a general rule, the preliminary sketch should be done in a medium that is compatible with the one that will ultimately be used.

Pencil is usually used for preliminary sketches to works in graphite, gouache, watercol-

### MORE ON THIS SUBJECT
- Specific materials **p. 60**
- Accessory materials **p. 62**

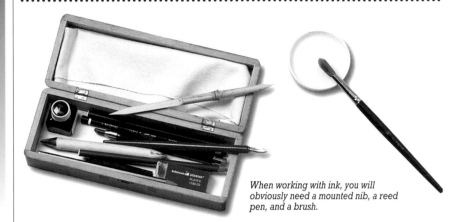

If your final work will be in charcoal, Conté pencil, or a regular or automatic graphite pencil, the sketch is done in the same medium.

The sketch for a work to be done in Conté crayon or pencil is begun in the same medium. Later, as the tonal values are established, white chalk can be added to the drawing.

or, or acrylic. With media that are diluted with water, it is best to use a watercolor pencil.

For oil, remember that the sketch is done in charcoal, then fixed with turpentine. After it dries completely, any extraneous charcoal dust that remains is removed with a cotton cloth. However, the preliminary sketch can also be done directly in well-diluted oil paint.

Pencil is normally used on paper, but the sketch for a work in acrylic can also be done directly in acrylic, whether on paper or canvas.

In a sketch for a transparent medium such as watercolor, the lines of the sketch must be very light. Otherwise, they will remain visible even after the application of color.

### The Box

You do not need any particular container. Any box—metallic, plastic, or wooden—with or without compartments, that allows you to store the drawing material neatly while protecting it from breaking should it fall is acceptable. Charcoal and Conté crayons can be wrapped in a cotton cloth or paper towel to protect them and avoid covering everything with dust. A graphite pencil, Conté pencil, eraser, pencil sharpener, and Exacto knife should also be included.

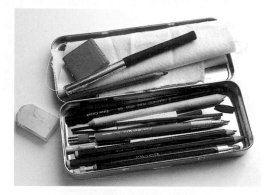

*It is convenient to have a box with the drawing materials you may need.*

*The sketch for an ink drawing can be done in graphite pencil applied very lightly. You can remove it completely by erasing it once the ink is completely dry.*

### Quick Sketches

In a quick sketch of an element of vegetation, only the most relevant aspects of the form and tonal value are drawn. These initial sketches are very useful because they allow the artist to begin working on the definitive support with a clear idea of the process to be followed. For these quick sketches, especially when working outdoors, it is very important to have a sketch materials box.

Quick sketches with monochrome tonal values do not depict the different colors of the vegetation. It is not unusual that some artists prefer to use markers or watercolors for a full-color sketch. If one sketch was tonal, the other would focus on defining the type of colors for each area. Van Gogh, for example, made at least two types of sketches on a single subject.

*Colored pencils and markers are suitable for sketches for works to be done in various media.*

# SPECIFIC MATERIALS

Each medium has materials that are specific to it and are indispensable for shading or applying color. These materials usually require complementary or accessory materials, without which they could not be used or the shading or color could not be applied. These materials are indispensable for working in each medium.

## Implements That Incorporate the Medium

In charcoal, the same stick of charcoal is used to apply shading. The graphite pencil, consisting of graphite lead inside a wooden cylinder, is the instrument of the medium, that is, the implement used to apply the medium carries the graphite in it. The same is true of colored pencils and automatic pencils (an instrument analogous to the pencil but which does not require sharpening). A marker, carrying ink, is at the same time the instrument with which to apply it. Sticks of chalk or pastel, or wax crayons are also the means for application.

## Pencils

Graphite pencils come in different lead types, ranging from very hard to very soft. The hardest lead has a metallic gray aspect when applied to

*Paintboxes or cases specially designed for oil painting will hold, in addition to the paint, the brushes and palette knives necessary to apply the paint. The box also includes containers to hold oil, paint, and jars of turpentine and linseed oil, essential for mixing and painting.*

paper. Graphite pencils can be used to make very fine lines provided the lead is sharpened. The softer the graphite lead, the darker the line produced, and the greasier it is. It also takes less effort to cover the paper. It is advisable to have pencils with different lead hardness when

*Colored pencils and markers are instruments that also contain the medium.*

working in pencil: hard, medium, and soft.

Colored pencils are a greasy medium in wax which are available in different qualities. It is a good idea to have some professional pencils that are not excessively hard. You can buy them in boxes of 12, 24, 36, 48, or more. Water-soluble colored pencils can be a good solution for field work. They are available in boxes, much like conventional colored pencils.

Pastel pencils combine the characteristics of a pastel as medium and a pencil as instrument. Their use allows you to develop techniques involving the line and the blending capacity of dry media.

## Markers

Markers are available in boxes with few or many colors. Markers for school use must be distinguished from professional markers. To use the appropriate techniques, it is important to know whether you are working with indelible ink. If it can be diluted, you should know whether the diluting agent is water or alcohol.

### Basic Materials

In some media, special tools are used for application. This is the case with oil, watercolor, acrylic, and gouache. An implement must be used for their application. The most rudimentary would be the finger, of course. For oil, a brush or a palette knife is normally used. Watercolor requires a brush. Acrylic and gouache, because they are thick like oil, can be worked with a brush or a palette knife. Ink is applied with a nib, a reed pen, or a brush.

## Ink

Many prestigious brands have broadened the selection of colored ink products. Some inks dry quickly and are indelible, while others can be manipulated while wet. They are similar to watercolors, but with a special finish resistant to both water and light. Jars are bought individually. Each artist selects his own colors, keeping in mind the possibilities of a universal palette.

*For outdoor painting in watercolor, a field painting kit is highly recommended. This box, containing dry cakes of paint, comes with a handle for more convenient use while working. It also has a small water container, a folding brush, a piece of natural sponge, a miniature pencil, and a small eraser.*

## Brushes

Different brushes are used for working in oil, watercolor, gouache, or acrylic. For oil or acrylic, the hair is usually more rigid and has more body than those typically used for watercolors or gouache. The latter must be very soft and flexible to glide over the surface of the support. Any shape or size tip for oil or acrylic brushes are acceptable. The shape of a brush designed for covering large surface areas in watercolor, gouache, or highly diluted acrylic is immediately recognizable and looks like a new shaving brush. When its function is to apply fine or small brushstrokes, the brush should have a fine tip. It should also be rigid.

## Palette Knife

Palette knives come in many different sizes and blade shapes. They are used in oil, acrylic, and even gouache to apply the medium directly onto the support as well as for mixing colors on the palette. It is practical to have a palette knife whose blade shape allows both functions. The palette knife allows the artist to add a very personal touch to a work.

## Functions and Media

There are many instruments that can be used to create a drawing or painting. The brush is the most common for wet media.

The palette knife is used above all with thicker media such as gouache, oil, and acrylic.

Stumps are specific to dry media, such as charcoal, Conté, chalk, and pastels.

Nonetheless, a brush can also be used to blend. A fan-shaped brush, is very useful for both dry and wet media.

*For works in pastel, you should have a selection of 36 or more colors and a cardboard, wood, or metal box, indispensable for their protection.*

**MORE ON THIS SUBJECT**

• Basic drawing materials **p. 58**
• Accessory materials **p. 62**

# ACCESSORY MATERIALS

In addition to the basic materials for applying the medium, accessories are often needed. Some of this complementary material is used in technical processes, while others are simply essential for cleaning and conserving the work. Depending on the medium, quick cleaning of the implements can be critical.

## Cotton Cloths

Cotton cloth is very useful, whether for use directly on the support or for general cleaning and preservation of the materials. A cotton cloth can be used to blend charcoal, Conté crayons, or pastel on the support. It can also be used to remove wet acrylic or oil paint from the canvas. You can use it too to dry your hands on it and remove any dust or paint from them.

*The easel is indispensable for holding a canvas or the backing for paper or cardboard. For watercolor and ink, the work should be kept horizontal, barely tilted toward the artist.*

*Turpentine is essential for cleaning the palette and brushes when working with oil paint.*

## Stumps

Some media require the use of special implements, such as stumps for dry media. They are available in different sizes in cylindrical shape, and generally have a conical point at each end. Stumps can be used to blend and extend the dust of any dry medium, such as charcoal, Conté, chalk, and pastel. They can also be used with graphite pencils, wax crayons, and oil pastels.

## Rulers and Squares

When working with paper or cardboard, it is often necessary to measure your support. For small formats, a square is sufficient. For larger formats, a ruler can be used.

These instruments are also useful to make small cardboard frames for framing subjects.

*Cotton cloths, always useful, become indispensable with certain media. Any old sheet or even a T-shirt will suffice for making rags as long as they are made of cotton.*

*Some paintboxes, such as this one designed for acrylic, have features that allow a support to be fixed on them for works in small formats.*

surface of an oil, acrylic, or gouache painting that is still wet, or even after it has dried. The Exacto can scratch away dry applications of ink, watercolor, gouache, etc.

It is important to put on the safety catch when not using the Exacto knife.

## Cleaning Products

Soap is necessary for cleaning your hands and the tools used. Materials for dry and water-based media only require

## Cutters and Scissors

Scissors and razor blades were indispensable instruments for the artist for many years. Today, the use of the Exacto knife has become widespread since it combines the features of several instruments. An Exacto knife can cut through cardboard, paper, and canvas. It can be used to sharpen pencils or sticks of charcoal, chalk, or pastel. With an Exacto the sgraffito technique can be applied to the

### MORE ON THIS SUBJECT

- Basic drawing materials **p. 58**
- Specific materials **p. 60**

### Caring for Your Hands

Some fine arts supplies are toxic to a certain extent. Others, such as dry media, cause your skin to dry, to say the least. India ink is difficult to remove from the fingers. Some colors in acrylic, oil, gouache, and even watercolor have strong pigments that dye the skin. Graphite pencils soil the parts of your fingers that come into contact with the lead or application. In general, you must clean your hands often. Keep a simple moisturizing cream on hand. A bit of cream will remove dirt. Furthermore, after washing your hands with soap and water (and sometimes even turpentine), it is a good idea to apply a substantial amount of cream to repair the skin. When working with dry media, it is best to wait until the session is finished before applying moisturizing cream.

*Hand cream and a soap dispenser are very useful when painting. The soap in the dispenser can even be accessed by pushing with your forearm if your hands are dirty.*

*You will need materials for cutting paper to the right format— scissors or an Exacto knife, a ruler, a square, etc.*

the use of soap and water. Oil also requires turpentine to remove the paint while it is still wet. Afterwards, hands and the implements are cleaned with soap and water.

Cleanliness and order are essential for the maintenance of drawing and painting materials. It is an effort that is well worth the trouble, as you will always have your materials ready when you need them.

# PRESERVATION

Each medium requires special care according to its characteristics. A final work may need the application of a fixative to preserve it. Then, some minimum conditions must be fulfilled to guarantee temporary preservation, but the means for this must also be considered.

## Immediate Precautions

Works done in charcoal, Conté, chalk, or pastel are often preserved with the application of a fine layer of fixative, generally available as a spray.

For oil and acrylic, final varnishes are available in gloss or matte. The choice depends on the artist's intention.

Other media, such as ink, do not need any protective layer after the work has been completed.

## Portfolios and Protective Paper

All drawings and paintings done on paper or cardboard require a rigid portfolio to protect them while they remain unframed. The portfolio size depends on the artist's works. Usually, an artist will have several portfolios of different sizes.

Each work should be protected on the painted or drawn side with laid paper, tracing paper, or tissue paper.

### The Functions of a Frame

A frame is not only a protective device for a work of art. It also has a decorative function. The frame is chosen according to its harmony or contrast with the colors or general tones of the work. The exterior frame, the passe-partout, and its beveled edges can become a center of interest in and of itself.

## Temporary Protection

There are interesting portable frames on the market which are not definitive but which protect works on paper or cardboard. They open like a folder and both sides are rigid. One side is made of transparent plastic with an inner frame that serves as a passe-partout. Inside one of these temporary frames, a very fragile work in pastel or charcoal, will not be smudged by accident.

## Frames

Frames are the most definitive form of preservation. For dry media, media worked in a dry manner, watercolor and gouache, on any type of support, the frame must include a sheet of glass or piece of transparent plastic. The passe-partout creates a protective air chamber between the work and the glass.

On the other hand, a work in oil or acrylic on a canvas with stretcher only requires a wooden frame.

*For temporary protection of works done in dry media, watercolor, gouache, ink, or markers, you'll need portfolios in various sizes.*

*Dry media need a fine layer of fixative. It is easier to apply fixatives from a can rather than in liquid form, which requires a nozzle.*

*A pastel painting requires a good frame for permanent preservation.*

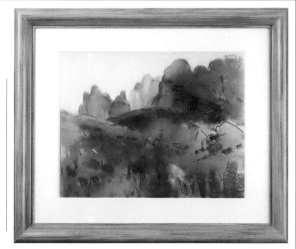

## The Frame and the Passe-partout

Frames come in a variety of colors, relief, and cross-section shapes. Many styles can suit a work.

A passe-partout is a cardboard frame covered with colored paper or fabric. If covered with paper, it is finished with beveled white or off-white edges. Passe-partout covered

*There are aluminum frames for works done in ink, watercolor, etc. They normally include the frame in four parts, the elements to join them, the glass, and a backing.*

in fabric are usually used for oil paintings.

The objective of the passe-partout is to ensure preservation of works done in dry media, but when used for an oil painting, its function is entirely decorative.

*For oil paintings and some acrylic paintings on canvas, the protective glass is not essential for framing, although a suitable passe-partout can always be added.*

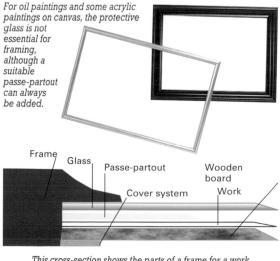

**MORE ON THIS SUBJECT**

- Supports for dry media **p. 54**
- Supports for wet media **p. 56**

Frame — Glass — Passe-partout — Wooden board — Cover system — Work

*This cross-section shows the parts of a frame for a work requiring glass protection: the frame itself, generally of wood, the passe-partout, the work itself, the backing, and the attachment system.*

*The color of the passe-partout is an important decorative element that can enhance a final work.*

# THE OBJECTIVE AND ANALYSIS

Representation, through a specific medium or even mixed media, is the goal of the artist. The preliminary step is analysis. The composition is studied with regard to the framework, the blocking in, and the general color scheme.

## Analysis for a Representation

There are several factors that are involved in an analysis for a representation. The composition corresponding to the chosen framework suggests a simple shape within which the focus of the subject is integrated with the essential aspects of the subject. The composition should have a balance of color masses and achieve a vision of unity within a variety of forms and their distribution.

Therefore, two aspects must be distinguished in the analysis. One refers to the diversity of shapes and lines. The other involves establishing the color scheme.

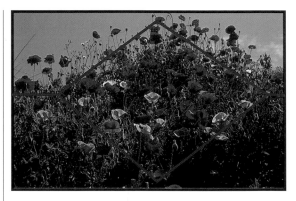

*The first step is to choose an attractive framework. The focus of interest should be placed within the golden section.*

*The basis is always a simple-shaped composition. The analysis has simplified the model in this case into three basic areas: the sky, the centered trapezoidal figure, and the lower dark area.*

### How to Apply Color and with What Implements

Before applying paint, it is best to carry out an analysis to determine the specific objectives. The space of the representation must not only be covered with shading or color, but the direction and intensity of execution must also be determined.

This is a good time to begin to think about the most appropriate tools, those which will be the basis of the work. A representation always reflects the lines or brushstrokes characteristic of these implements, although personalized by the artist.

## Deciding on a Palette

Before beginning a representation, you must choose the palette. Studying the model of vegetation and its surroundings, whether it be indoors or out, will show the superiority of one set of colors over others. This analysis simplifies the

task of mixing on the palette (for oil, acrylic, watercolor, ink, and gouache). It also facilitates the selection of colored pencils or pastels from a wide range of possibilities. With these two media, more luminous and clean color mixtures are obtained if they are made from many colors according to

to avoid their showing through in the final work.

## Then, Fill the Space

After the space is delineated on the support, it must be filled by shading or coloring. The color applications are placed next to the other or in superposition. Successive applications are added to progressively model the different shapes of the model through color. Vegetation is represented through the various textures that every medium allows.

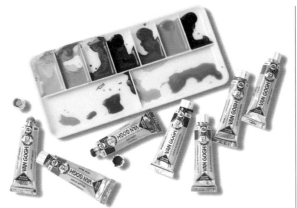

*The most appropriate palette is chosen to paint the model selected. Let's discuss the case of watercolor, for example. The colors needed are light yellow, yellow ochre, vermilion, carmine, cerulean blue, yellow green, and sap green. You will need two water containers— one to clean the paintbrushes with, and the other for clean water.*

the techniques appropriate to each.

When choosing the palette, the artist mentally establishes the color scheme that will govern the representation.

## First, Limit the Space

Begin by drawing lines that establish the space to be occupied by the representation. These are the master lines that allow the most important color masses to be placed. This blocking in is done by taking measurements to keep elements in proportion. Except in a very accentuated foreground, at this point of the drawing or painting process, the master lines will not show the characteristic aspects of the vegetation in detail.

These master lines are done in the media most appropriate for the definitive work. Keep in mind that media such as watercolor, oil, and acrylic (when used in a transparent manner), light inks, markers, colored pencils, and even wax crayons require very light master lines

| MORE ON THIS SUBJECT |
| --- |

- The horizon and planes **p. 8**
- Composition **p. 10**
- Light and distance **p. 22**
- The palette **p. 26**
- The preliminary sketch **p. 32**
- Tonal values **p. 34**
- The medium and its stages **p. 68**

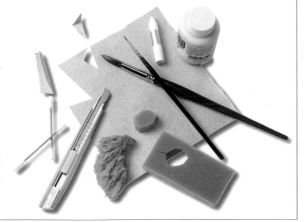

*Once the palette has been chosen, the sequence of application of the different processes to be used must be established, as well as the implements needed. White wax and masking liquid should be present just in case. Brushes are used for washes. Sponges and Q-tips can be used to apply or remove color. Blotting paper can dry areas totally or partially. The Exacto knife can be used to scrape off paint and recover white surfaces.*

# THE MEDIUM AND ITS STAGES

In order to represent the foreground, middle grounds, and background, the color structure is designed for greatest effect. To paint or draw vegetation, from the first application of the medium, the techniques appropriate to each effect must be used and applied in the right sequence.

## Techniques and Representation

Foreground, middle ground, and background are treated differently. To fill the space of the support, the areas corresponding to each ground use the technique most appropriate for achieving, respectively, an effect of proximity, middle distance, and far distance.

Textures are related to the effects desired. To obtain a texture, specific steps must be taken in a methodical order. Nonetheless, in a single work, different areas call for different treatment, and so it is necessary to establish the overall color scheme.

## Color Structure

To achieve the effect corresponding to each ground (foreground, middle ground and background), there are ideal techniques in each medium. The background in watercolors is best done in washes of pale colors on wet paper and with varied color mixtures. To describe vegetation in the foreground, the artist could work in stages and use the technique of wet oil on dry. When working in pencil, a light shading can be used for the background, pointillism for

---

**MORE ON THIS SUBJECT**

- The objective and analysis **p. 66**
- Transparent or opaque oil **p. 70**
- Watercolor and its techniques **p. 72**

---

### Color Areas and Local Color Points

The general color structure is established for large areas. Details are added later. Therefore, the general scheme should be designed to take into account the later detail work to allow it to be progressively incorporated.

the middle ground and cross-hatching for the principal elements of vegetation, finished off by energetic artistic lines.

*A second application on the first when it has nearly dried allows the vegetation to be fully defined.*

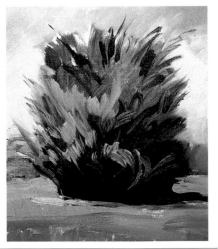

*The first layer of an oil painting describes the volume of elements of vegetation.*

*A watercolor design may require an area of paper to be reserved with masking fluid.*

application of one color before another. Practice demonstrates that these general analyses, apparently so complex, are not difficult.

## The Most Appropriate Sequence

There is a logical process for establishing the general color structure, given that it must be designed so that the sequence of steps is adapted to the medium.

Some techniques cannot be applied before other techniques. For example, with watercolor, the wet on dry technique cannot be applied if the first layer of color has not been allowed to dry. Nor is the cloudiness of the wet on wet technique achieved if the paper has not first been wet or if the first layer is no longer very wet. A transparency in oil is less luminous if the first layer of color applied, the one underneath that is completely dry, is not the lighter color.

## Sequence and Chronology

The overall color structure requires a sequence in the application of the different procedures and techniques involved. The order depends on the requirements of each medium. There are the drying requirements of wet media that take a certain amount of waiting time, and the rules of color mixtures that call for the

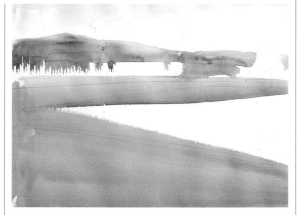

*In a watercolor landscape, color is often first applied with a great deal of water.*

*The subsequent washes usually contain less water and are often applied as wet on semidry or on dry.*

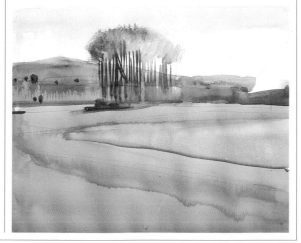

# TRANSPARENT OR OPAQUE OIL

Oils can be treated in several ways. The effects and textures created are very different.
When it is highly diluted, it is transparent, whereas when it is very thick, it is opaque.
A specific sequence of applications allows techniques to be alternated, using all
of the versatile resources that oil offers.

## Transparent Oil

Oil requires a highly diluted and quite transparent first layer. To prevent cracking, a good deal of thinner must be applied to the paint. A first layer applied judiciously could be used as the definitive color and texture for the background.

## Transparencies

The technique of transparency can be used by applying a transparent layer of color over a background color that enhances it. The transparent layer is applied only after the previous layer has dried completely. Otherwise, the two layers will mix, and a clean, luminous transparency will not be achieved.

The transparency technique was fundamental to academic painting, where the surface of the canvas was maintained quite smooth throughout the work. Today, the majority of artists do not execute a work wholly through the technique of transparencies.

### Local Transparencies

Transparencies introduce very colorful texture variations. A localized transparency allows the introduction of color hues by superposition in a different manner from physical mixtures. The transparency has the effect of harmonizing all the colors beneath it.

Local transparencies are also very useful for expressing reflections.

### Opaque Oil

Oil that is not too diluted is highly opaque. Working in this manner, the artist can apply paint thickly, in other words,

using the impasto technique, and the surface can be easily scratched by sgraffito. The brush hairs themselves leave perceptible lines in an impasto, When the blade is used flat, the palette knife leaves smooth surfaces, but when the edges or tip are used, a sgraffito of sorts is produced.

### Alternating Opacity and Transparency

The infinite possibilities of oils become apparent when different techniques are alternated on a single canvas. The contrast between transparent and opaque, smooth brushstroke and impasto, layered transparencies, frottage, and sgraffito create different textures.

**MORE ON THIS SUBJECT**

• Oil **p. 40**

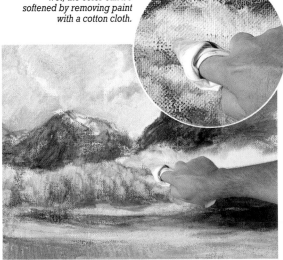

*On an initial layer of paint that was diluted and is still wet, the color can be softened by removing paint with a cotton cloth.*

*The more diluted the oil, the more transparent the application. The first application should be well diluted to prevent the paint from cracking later when it dries.*

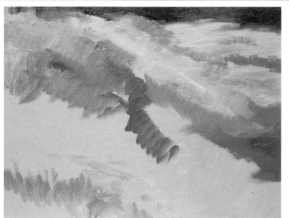

*The first layer is applied with oil that is well diluted and quite transparent. This first layer can be easily corrected by removing the paint while it is still wet. Once dry, it can be corrected only by covering it with another layer of paint.*

*In the subsequent layers, the paint applied is thicker. In this way, they can be incorporated into the still wet underpainting, or even cover it if it is dry.*

## Corrections in Wet Oil

Corrections in wet oil are immediate. If the area to be modified is large and the paint is thick, use the palette knife to remove most of it. If only a little paint is left, you can paint directly on top of it without waiting for it to dry. The remaining paint can also be removed completely with a cotton cloth dipped in turpentine. You can paint on the canvas once it is dry.

## Corrections on Dry Oil

Opaque oil is very useful for covering errors. Corrections on dry paint only require the surface to be smoothed previously with sandpaper. Then the area is covered with oil paint thick enough to completely cover the color and texture of the previous layer.

## Corrections and Transparency

It is more difficult to use the transparent qualities of oil on a corrected surface.

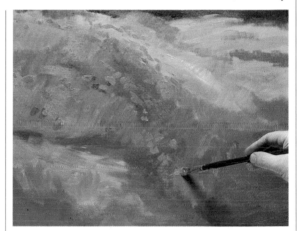

*The last details that refine the vegetation are applied with thicker paint, without the addition of thinner. Thus, the last brushstrokes are highly opaque.*

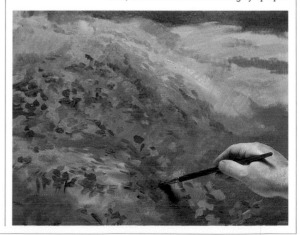

TECHNIQUE AND PRACTICE

# WATERCOLOR AND ITS TECHNIQUES

Watercolor techniques are directly related to the way in which water
is used. Very different results are obtained in watercolor using wet on wet,
wet on semidry, and wet on dry techniques.

## Vegetation and Watercolor

Regarding the degree of definition of shapes and the refinement of color, the most effective technique must be used to produce the effect of distance, middle distance, and proximity. This means using the wet on wet techniques and various mixtures to convey the feeling of distance. As intermediate and closer grounds are represented, the technique of wet on wet is progressively replaced by that of wet on

### MORE ON THIS SUBJECT

- Watercolors **p. 44**
- The objective and analysis **p. 66**
- The medium and its stages **p. 68**

semidry and eventually on dry. To paint vegetation in watercolor, the drying time of each wash must be controlled.

## A Variegated Wash As a Background

The technique of wet on wet to represent vegetation in the background requires great control of the moisture content.

A procedure that usually provides excellent results is to first wet a specific area of the paper with clean water. Then, with the right color, the wet surface is lightly dabbed with the brush. The color expands and produces excellent effects. This first wash can be completed with light touches of other colors. The mixtures produced are exquisitely variegated.

### Reserving White Areas

The practice of reserving white areas is typically used for representations of small elements that need contrasted profiles. They are often surrounded by spaces that must be painted in very wet washes.

To paint vegetation in the distance, watercolor can also be applied directly on the dry paper. The success of this procedure depends on the wetness of the wash and the speed with which it is executed. A thick brush should be used that can carry a lot of water.

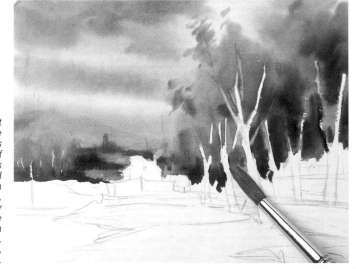

*To paint vegetation in the distance, such as in this row of trees, watercolors are applied using the wet on wet technique, partially modifying the washes with orange, ochre, sienna, and sepia.*

*The first step is to reserve white areas with masking fluid. The masked area of the paper is not colored by successive washes.*

*The subsequent general washes are achieved in the wet on semidry or wet on dry techniques. Once the paint is dry, the masking fluid is removed by rubbing, as if using an eraser.*

## Drying Time

If a brushstroke is applied quickly over a previous one, the mixture is rich and the edges imprecise. The longer the waiting time between brushstrokes (over a semidry wash), the more defined the profiles of each stroke. On a completely dry wash, the definition is high. The drying time is the variable that must be controlled to obtain the desired effect. Seconds count with a semidry wash so the paint must be applied progressively and in order, from most distant area to the foreground.

Artistic brushstrokes are used to create volume in the distance.

## Wet on Dry for Definition

Intermediate grounds can be developed by controlling the wetness. But, vegetation in the foreground requires a degree of definition that can only be achieved by painting wet on dry.

The brush size is usually fine, always in proportion to the work to be done. In this detail work, it is better to use a firmer brush than those used for the large washes. This area must be painted by drawing the elements.

*When the white areas are recovered, brushstrokes of light or luminous colors can be applied without any risk of their bleeding into the surrounding colors.*

# THE ARTISTIC SKETCH

Blocking in provides an approximation of plant forms and allows the element
of vegetation to be placed in a context and within the total space of the
representation. The artistic intention in lines and strokes gives
the final work its artistic appearance.

## Purposeful Brushstrokes

Vegetation can be represented with just a few lines based on simple geometric figures. This manner of sketching is useful for determining the area that an element will occupy on the paper or canvas. It also provides an idea of the impact its color may have on the overall picture.

However, the definitive description of vegetation can only be done through artistic strokes. They capture all of the plant's features. Their profiles correspond to the perspective in which the vegetation appears.

**MORE ON THIS SUBJECT**

• The preliminary sketch **p. 32**

*Blocking in with simple geometric figures establishes the space to be occupied by an element.*

*An artistic sketch delivers more information on this model.*

## Tonal Sketches

A tonal sketch is a rapid study in which tones are selected. Media such as watercolor, gouache, and acrylic allow tonal sketches to be done quite easily. In a single color, using all of its tones, a very complete tonal sketch can be achieved.

Tonal sketches are usually not used as part of a final painting. This is easy to demonstrate in watercolor. When transparencies completing the color of a landscape are applied over a dry tonal sketch that would act as an underpainting, the result is not as luminous and fresh as we expect from watercolors.

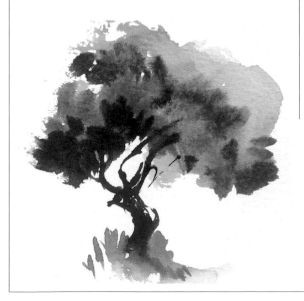

*In a medium such as watercolor, some artists do not even carry out preliminary pencil sketches. Instead, they prefer to do quick sketches in watercolor, like this one, on a piece of paper to study the possibilities. In a study such as this one, the sequence of washes is established.*

## Sequential Studies

Studies establish the general master lines. The tonal study provides information on tonal values. The full-color sketch develops the colors to be used, and a sequential study is a rough draft of the order of the different procedures to be used. The purpose of this type of study is to clarify the color structure within the order of alternating techniques. It is an analysis, an overall study, to establish how to treat large areas and their later tones and values, until the entire range of colors and textures needed has been established.

## Quick Studies

Quick sketches in full color often have an undeniable

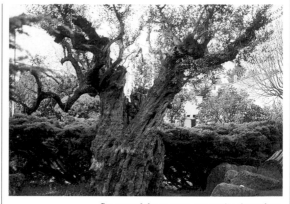

*Some models are more suggestive than others. This twisted olive tree is an example.*

single motif in the vegetation, such as a tree, a flower, etc.

## Markers

Markers are a perfect medium for studying the direction and intent of the strokes to be done in a definitive work, and to capture the volume of the elements involved. They can be used to create the rhythm most appropriate to the final representation.

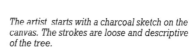

*The artist starts with a charcoal sketch on the canvas. The strokes are loose and descriptive of the tree.*

*The interpretation that could be visualized from the sketch was resolved with the same curves as in a work in oil.*

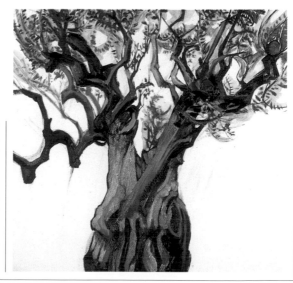

freshness because of their spontaneity. Watercolor is a medium that allows quick, full-color studies of vegetation. The paper should be small. Therefore, washes are short, as the area to be covered is limited. Problems due to degree of wetness are minimal.

Quick full-color studies are often used as a preparation for a larger work in watercolor. Sometimes they refer only to a

# PERSPECTIVE AND PHYSICAL PHENOMENA

There can be several perspectives of a single vegetation model, each of which presents different problems. The view relevant to each case must be studied and applied to the specific position of each element of vegetation. Keep in mind that the effects of the force of gravity or the wind can be observed on any type of vegetation.

## Studying the Bending of Branches and Leaves

There are many cases of vegetation in which the weight of the leaves or flowers and the suppleness of the branches or stem give it a distinct appearance as it bows down under the force of gravity. This is the case with a willow or a fruit tree sagging under the weight of ripe fruit. In this case, capturing the type of bending is very descriptive. There is a rhythm particular to each element of vegetation.

*The presentation of the willow must express the characteristic bending of its leaves and finer branches, implying verticality.*

No matter the medium, the possibilities of creating texture to produce the desired effect must be studied. To achieve it, in addition to the traditional implements like the brush and palette knife, any other instrument that affords a good descriptive effect can be used.

For example, sponges with different consistencies and textures can be used. It is interesting to experiment with the type of marks they leave, as they are very useful for developing details in any ground. Nonetheless, anything will do, like a piece of potato or an

*The direction of the brushwork and washes are always done in accordance with perspective. Observe the gesture in the watercolor strokes that represent a path receding into the landscape.*

*The watercolor brushstrokes in the foreground, done on dry paper, capture the movement of the swaying reeds with great realism.*

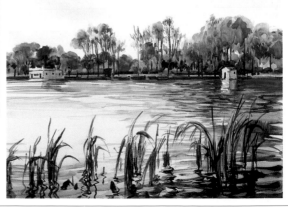

eraser. The point is to successfully express the details of the vegetation.

## Calm, Breezes, or Wind

A light breeze will sway the grass in a field. In a wheat field, the ears of wheat move in a special manner—they produce a wavelike motion. In

*Background vegetation can be suggested in oil with a natural sponge, for example.*

### The Instrument and Texture

When working in a medium through brushstrokes, such as oils, watercolors, etc., they must be descriptive of the different directions that make depth evident.

From a distance, the brushstrokes, even varied ones in the case of watercolors, are descriptive of verticality. In the middle ground and foreground, brushstrokes are applied in directions that enhance the focus of the model. Inclines are described with vertical strokes while dips in the land follow the line of the path.

To describe a wheat field, the height of the ears must be expressed along with a flat, undulating surface. The palette knife can be a great instrument for texturing a wheat field in oil.

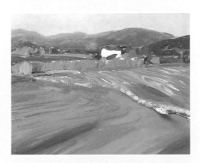

*Vertical brushstrokes and tonal work add texture to the hedges in the middle ground. The palette knife allows the separations between fields to be textured in oil.*

### Applying Perspective

A landscape with vegetation, even one with the simplest perspective, must be planned carefully. The first task is to locate the horizon line. The frame must immediately convey the sensation of depth, whether by vegetation in the foreground, or of elements that serve as a bridge between the model and the viewer.

Perspective for outdoor themes often uses a path that recedes into the background. The few master lines in an attractive framing tend to enhance a point of interest which, in a nearly intuitive manner, is almost always located within the golden section.

---

**MORE ON THIS SUBJECT**

• The horizon and planes **p. 8**

---

strong winds, even thick trees sway in the direction of the wind. The thinner branches and leaves also flow in the direction of the wind.

Vegetation on a still day is static and has a specific texture. Clearly, the force of wind, changes the texture.

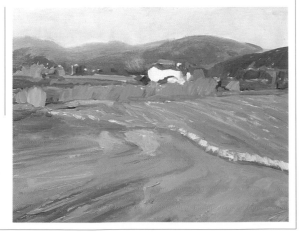

*The brushstrokes of M. Braunstein that texture the fields in the foreground define the direction of the rows and model them in depth.*

TECHNIQUE AND PRACTICE

# VOLUME

To express depth in a two-dimensional representation, as is the case on paper
or canvas, a model should be found. The artist uses color and texturing
to enhance volume in a work.

### Different Proportions

The feeling of volume can be emphasized through the use of some element of vegetation in the foreground. The introduction of elements with different proportions always accentuates the feeling of depth.

With drawing media, the study of proportions is essential. In charcoal, graphite pencil, or Conté, measurements are successive. The texture of the cross-hatching or shading and colored areas without patterned lines progressively develops the representation while respecting its lines.

Pastel is both a drawing and a painting medium that allows vegetation to be rendered in a drawing, or a painting, or both. The techniques of coloring, gradation, and blending in pastel are exceptional vehicles for describing vegetation in an astonishing chiaroscuro and complete realism. In the emphasis on color, pastel allows a burst of colors which goes beyond what we see in nature and is a masterful interpretation of the subject.

In painting media, the sketch is based on a few general lines, while the real study for the drawing progresses through color. In addition to suitably providing the texture of oil, acrylic, etc., it must correspond to each ground as well as to the colors used.

### Texture

One way of suggesting depth and volume is to treat the elements appearing in the

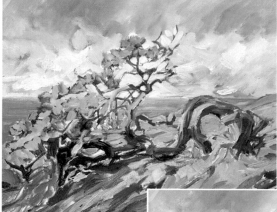

*In the initial blocking in, the areas of light are basically established. The general work here does not go into too much detail.*

*The modeling of color and tone is done in the next stage. These are short brushstrokes compared to those of the initial blocking in. Every brushstroke must be descriptive and offer good contrast to the others surrounding it.*

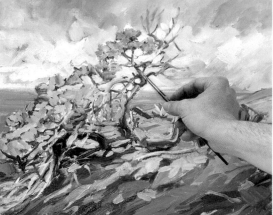

| MORE ON THIS SUBJECT |
| --- |
| • Tonal values **p. 34** |
| • Gradations **p. 80** |

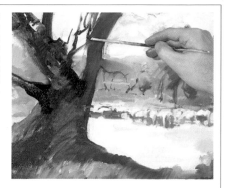

*Modeling an element, in this case a tree in oil, is always done on the structural basis of the initial roughing-out.*

foreground, middle ground and backgrounds differently. Media that can be applied thickly or finely, such as oil or acrylic, allow depth to be dramatized in an immediate manner. Oil or acrylic can simply be used in a highly diluted form to express distance. Denser layers can be added while progressing toward the foreground.

## The Direction of Light

Due to its luminosity, watercolor is a medium well adapted to treating themes with accentuated contrasts between dark and light.

How does one achieve bright shadows? There are general guidelines for working in watercolor. When the superposition of layers is used, that is, the technique of wet on dry, the brighter layer must be placed underneath. Complementary colors should be avoided. To darken the color, another darker color of the same group should be applied first.

When blue is used to darken, cerulean blue and light cobalt blue are the colors that provide the most luminous shadow. Washes in those blues, without superposition and highly diluted, offer great contrast to the lighted areas, and are very luminous themselves.

The brightness of shadows in oil requires careful palette work. Avoid muddy mixtures (be careful with the use of complementary colors) as well as excessively blackened ones (do not use black for mixtures but rather mixtures for "blacks that can be modified").

*In the modeling, the play of light and shadow must be correctly depicted. In this case, the vehicle is watercolor. The color of the brushstrokes by Manel Plana, their tone, and the direction of application enhance the feeling of depth.*

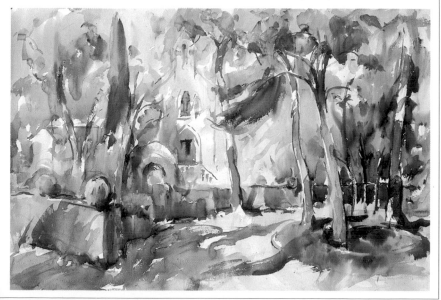

# GRADATIONS

The technique of creating a gradation exists in any medium. It is used to describe the progression from light to shadow and/or from one color to another. The artist uses gradations to create volume with the most appropriate texture.

## Drawing Media

Gradations through cross-hatching or coloring serve to express the progression from light to shadow, without abrupt changes in tone. The expression of volume depends on the system used to create tonal contrast. A gradation can be progressive or can be achieved through optical mixtures. The most important thing is that the system of contrast can be employed with overall consistency on the work.

With colored pencils using the tonal technique, splendid gradations can be created, but it is also possible to use extensive ranges of colors and develop depth directly through the colors with few mixes.

*The leaves here are developed through gradations done with several green pencils.*

*The gradation adapts to the form in each element, in this case, to the spherical shape of cherries.*

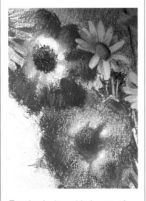

*Tonal coloring with the use of white pencil allows very delicate gradations.*

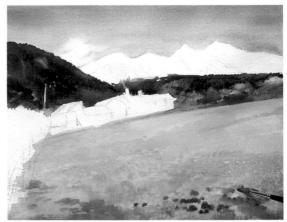

*In watercolor, the use of a gradation in a foreground immediately creates a sensation of depth.*

**MORE ON THIS SUBJECT**
- Tonal values **p. 34**
- Volume **p. 78**

## Pastel

A gradation can be used as a background surrounding an element of vegetation, or as a base on which to texture the characteristic details of the motif. When the volume is spherical, such as that of a cherry, or specific, such as that of a leaf, gradation is created by modeling the shape.

## Oil and Acrylic

A tonal gradation can be created in two ways. With opaque, thick paint, white paint must be added progressively to obtain lighter tones. With transparent layers of color, tones are achieved by transparency over the white canvas. Remember that oil is transparent when it is highly diluted, by adding 50% turpentine and linseed oil. Transparency is obtained in acrylics by diluting the paint in an acrylic thinner, adding an abundance of transparent dense gel, or even adding a great deal of water.

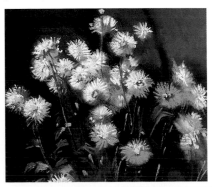

*Roughing-out in oil with gradation is a perfect base for contrasting with a second application of paint without gradation (in this case, the depiction of the tree in the foreground).*

## Watercolor

Controlling water is the crucial factor in watercolor gradations. For a tonal gradation, normally a local wash is done in one color. Clean water is added to the brush and the wash is executed as if dragging the color along the paper, attempting to achieve a gradation and not a homogeneous color.

If a gradation must be made with two colors, first one color is applied and tonally graded. Immediately after, while the first wash is still semidry, the second color is added in another tonal gradation but beginning in the other direction and partially covering the first one.

Gradations, including those in which various details appear, are a very appropriate base for expressing details in the foreground, applying more color on top but using the wet on dry technique.

*The effect of depth achieved when the background of a work in pastel is subtly gradated is spectacular, especially if the initial stage is compared to the finished work.*

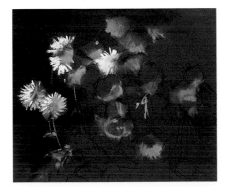

# MIXTURES

The color you need may not always be available on the market. In general, in the majority of wet media, color is sought through mixtures. Media such as pastel, pencils, and markers, among others, come in a wide range of colors. Mixtures are usually done using the techniques appropriate to each medium.

## Homogeneous Mixtures

Homogeneous mixtures are mixtures in which the colors involved can no longer be perceived individually. What is visible is a uniform color different from any of the original colors.

This type of mixture can be obtained through dry media if the colors are applied properly. For example, homogeneous mixtures can be created from several different colors in Conté, chalk, pastel, or wax cray-

### MORE ON THIS SUBJECT
- Texture up close **p. 28**
- Texture at a distance **p. 30**
- Gradations **p. 80**

on. Wet media always allow homogeneous mixtures. Oil, acrylic, watercolor, gouache, and ink are suitable media for such mixtures.

In developing an element of vegetation, this type of mixture is used particularly to describe a flat surface with a smooth texture. Gouache and acrylic can be used in a very immediate, flat manner.

## Blending

A blend is obtained when colors are manipulated directly on the paper or canvas until a homogeneous mixture is obtained by repeated friction. The blended colors appear matte or dull. Blending is done with the fingers and a brush (for wet media with body), or

*In this landscape, the artist, Marta Durán, obtains a great effect with light. The thick impasto and mottling are divided between two groups—the area of light and that of shadow. She used a delicate palette with neutral colors that soften contrasts.*

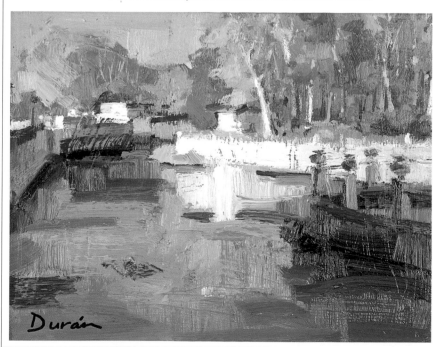

Durán

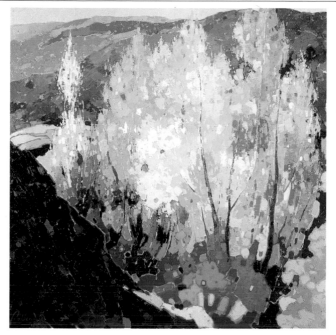

*The artist Pedro Roldán attempts a very different treatment. He achieves the impact of this work with a careful contrast between a cool color range (of blues and greens) and a warm one (ranging from yellow to orange).*

with the fingers and a stump (for dry media). The texture of a blend makes it suitable for expressing prominent areas of a volume and even for highlights.

Oil, acrylic, and gouache are wet media that can be blended if they are used thickly. Any of them can be used to create a blend of two or more colors. Dry media, such as Conté, chalk, or pastel, can also be used for blending.

## Optical Mixtures

An optical mixture is a mixture in which, when viewed close up, several juxtaposed colors can be perceived. There are many ways of creating optical mixtures, depending on the media and implements used. Pointillism is often used for elements of vegetation. In other cases, the texture afforded by an optical mixture is a good means of expressing relief with immediacy.

### Frottage and Mottling

A frottage begins with a layer of paint that is already dry. A brush with another color is then rubbed across the surface of the dry layer. It can be done in any wet medium.

Frottage is a technique that produces optical mixtures and can be used to add color tones.

Mottling allows for the creation of an optical mix in thick wet media. The first layer is applied densely and thoroughly. While it is still wet, another color is lightly rubbed across the surface of the wet paint with a palette knife. The result is a surface mottled in both colors and mixtures.

The colorfulness of mottling allows the creation of textures that are very appropriate for representing vegetation in middle grounds.

### Superimposing of Layers

Another manner of obtaining a mixture consists in superimposing layers of colors. This technique is common in watercolor with the wet on dry technique. It is also used to create transparencies in oil and acrylic.

# DEFINITION AND IMPRECISION

The manner of applying paint allows the creation of a specific degree of definition. Each wet or dry media has its techniques and sequence of procedures for obtaining areas that are defined or undefined.

## Definition and Contrast

Definition is obtained through contrast between colors, whether this involves color areas or lines. In any medium, wet or dry, contrast is assured through color and by resolving the point of juxtaposition of color areas or lines.

Contrast between colors depends on the characteristics of each color. Maximum contrast is obtained between two complementary colors at their maximum intensity. The complementary colors are: primary yellow and secondary blue, secondary red and primary blue, secondary green and primary magenta, yellow-

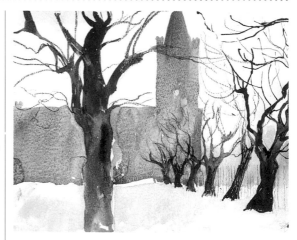

*Watercolors can be used to create a strong definition as long as it is applied in the wet on dry technique.*

green and violet (tertiary colors), blue-green and red (tertiary colors), and orange and blue (tertiary colors). Contrast diminishes when less intense tones are used.

Definition in outlines not only depends on the color and its intensity, but also on the definition of lines. An outline obtained by mottling, frottage, or other types of optical mixtures is not perceived as precisely as one done with a clearly linear intent. Part of the degree of definition depends on the texture created by the paint.

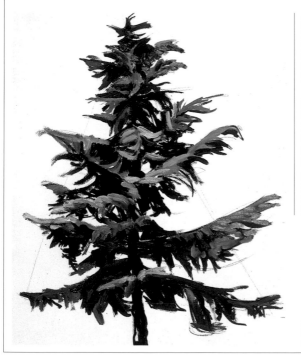

*Gouache is a type of paint that allows an immediate effect of definition.*

Highly watered-down watercolor allows representations with a high degree of imprecision. Such watercolor paintings are very artistic. Work by Manel Plana.

## With Dry Media

Intensity in the outlining stroke or line is the basic requirement for obtaining definition. Definition can be obtained on light or dark colors. Pastel artists usually color in two different manners. The direct manner involves coloring an area, but it is also common practice to color an object negatively by coloring around it. To do this, the outline is darkened or lightened, that is, the outside of an area is colored instead of the inside.

## Painting on Dry or Wet Paint or Paper

When discussing wet media, a distinction must be made between the media and their manner of application.

With a very transparent medium applied in a thin layer, such as watercolors, contrast is created through the characteristics of the colors, their intensity, and the use of the wet on dry technique. Whether through superposition of layers or juxtaposed ap-

plications of color, the most subtle contrast in watercolors is obtained by using highly diluted paint and creating very clean and light shadows. The wet on wet technique can be used if the colors are highly diluted in water. When wet on semidry or dry is used, the ef-

fect of the superposition of layers must be evaluated. The colors must be chosen well in order to produce mixtures by superposition that are cleaner. The outline contrast can be reduced by adding clean water to soften the lines.

With an opaque medium such as gouache, oil, or acrylic, when used thickly, the degree of contrast between different applications of color depends on the characteristics of those colors, their intensity, and their texture.

### With or Without Intensity

In the two approaches with brighter tendencies, emphasis on values and emphasis on color, the contrast between definition and imprecision adopts an artistic balance. Emphasis on value is more in consonance with reality, whereas emphasis on color is based on an exaggeration of colors and contrasts. Each interpretation of a theme will have a point of imprecision in the treatment of the background.

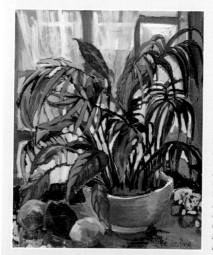

The definition of the foreground strongly contrasts with the imprecision of the background. The artist, Olivé de Puig, despite her broad, nearly flat brushstrokes in oil, creates a sensation of depth through the imprecision and decrease of contrasts in the background.

# HIGHLIGHTS AND REFLECTIONS

Highlights and reflections in a drawing or a painting provide contrast. Highlights represent points of maximum light, while reflections depend on the characteristics of the surfaces nearby and the source of light. Highlights and reflections, whether dramatized or not, constitute a very important aspect of a work of art.

## Highlights and Reflections

Highlights are the points of maximum light that the sun or other source produces on a vegetation motif. To represent them, the type of light must be considered, as well as the color of the vegetation. The color tone used to represent them is always light.

Reflections do not only depend on the light that illuminates a scene, but also on the characteristics of the two bodies that are close enough to each other to produce them. The colors used to represent reflections depend on the type of light, the colors of each body, and the characteristics of their surfaces.

Highlights correspond to the part of the element of vegetation that most protrudes and is thus most brightly lit. A reflection corresponds to a

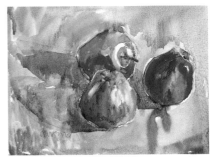

*This watercolor, in which the representation of the water is evidently structured with great mastery, perfectly captures the highlights and reflections of this bunch of apples.*

nearby area that is visible due to the reflection of the rays of light that bounce off the illuminated surface of the nearby body. Therefore, highlights and reflections enhance the modeling of volume and constitute the maximum instruments of contrast.

### MORE ON THIS SUBJECT

- Mixtures **p. 82**

## Whites for Watercolor

The case of watercolor is unique. As it is a transparent medium, brilliant highlights are best represented by using the color of the unpainted paper. It is common practice to reserve the highlight areas with masking fluid before beginning to paint. Once the painting is complete and has dried, the masking fluid is re-

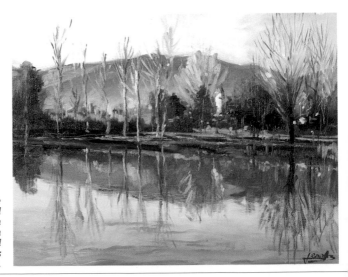

*The image of the vegetation reflected on a large area of water is an important pictorial element in this composition.*

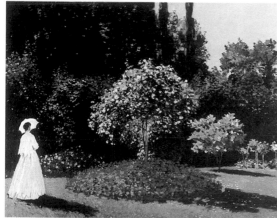

*Claude Monet.* Woman With a Parasol Turned Toward the Left. *The technique used to describe the light on the vegetation is based on simultaneous contrasts. A light color or tone appears lighter than the darker color or tone surrounding it. Conversely, a dark color or tone appears darker when surrounded by a light color or tone.*

### Drawing Highlights and Reflections

Highlights are usually represented by small dots or areas of color. They can even be represented by two or more crossed lines. Drawing a reflection, on the other hand, can be more complex, especially in a very visible foreground. A reflection is always a distorted image of the body it reflects. The artist must capture the source of the shapes created by the reflection and the distortion that the shape of the reflecting surface produces.

moved with a clean eraser. It can also be removed by rubbing it off with the finger. Masking liquid comes off easily. The immaculate white of the paper is thus recovered and constitutes a bright highlight.

### Reserving White Areas and Value

In general, the areas of highlights and reflections must be treated with special care, whatever the medium used to draw or paint.

Areas must always be reserved, at least mentally, to protect them. When coloring with a dry medium, these areas should be protected. As more color is applied, the areas continue to be reserved. Small reflections and highlights are usually added as the last steps of a work.

*John William Inchbold (1830–1888).* View of Montreux. *The light and reflections provide the dominant tonality of the work, which is most evident in the areas of vegetation.*

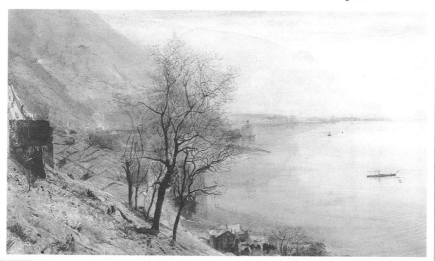

# NATURAL CONTRAST

Any scene has natural contrasts resulting from the light and the colors of the elements present. In a model with vegetation, the rendering of the color masses involves the entire palette. The strength of these natural contrasts must be studied.

## The Real World

What colors correspond to vegetation? Obviously, green is the color most often used. It has an infinite variety of hues.

But vegetation also includes flowers, fruits, and plants that are cultivated. So, in short, paintings that portray vegetation can have all sorts of colors.

## Contrast Diminishes

Natural contrast doesn't always have to be maximal. A field of wheat against a blue sky provides a dramatic contrast. However, the color of the sky does not always have the intensity of a secondary blue, nor does the wheat always have a crisp primary yellow color.

Stems and leaves are usually green, but some rosebush species have a very dark green, even violet hue. Roses also come in many colors. Each type of rose presents a contrast between the colors that correspond to the petals, the stem, and the leaves.

### *Maximum Contrast*

Maximum contrasts are a common phenomenon in nature. They often occur between the two complementary colors, green and red. Maximum contrast occurs between red poppies and a green meadow, a red rose and the green of its leaves and stems, or ripe cherries in the tree. Many reds and greens appear in juxtaposition.

### Painting What You See

When painting directly from nature, the natural contrasts must be represented. If we paint them exactly as we perceive them, the contrast depends directly on the influence of the light that illuminates the scene.

The light can become a factor that naturally harmonizes the colors present. The type of light implies a dominant color that permeates one's view of the vegetation at hand. In some cases, it is easy to evaluate, for example, in a sunset, which is clearly tinged with orange. In other circumstances, it is more complex, such as with interiors, in which contrast is often invented.

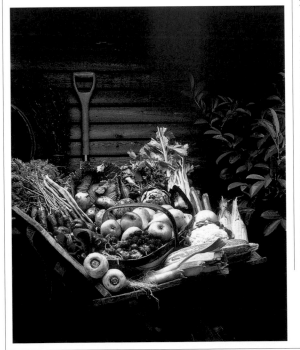

*Natural contrasts can be very strong. The elements can be complementary.*

*It is worth comparing the photograph of the landscape and Ballestar´s treatment of his painting in watercolors.*

*An artist can try to capture what he really sees, but the medium requires a small amount of interpretation.*

**MORE ON THIS SUBJECT**
- Harmonization **p. 90**
- Interpretation **p. 92**

When the dominant color can be determined, it is used as a structural system for palette work. The dominant color is usually added in very small quantities to mixtures to create the colors of all the elements appearing in a theme. Once a work is finished, the entirety of it reflects a tendency toward the dominant color. Mixtures in which the dominant color could be complementary to the color of an element are done with particular care.

### The Use of Complementary Colors

Subtlety depends on the correct use and application of complementary colors. To avoid excessively violent contrasts by juxtaposition, indirect complementary colors are used while very intense tones are avoided.

Unpleasant maximum contrast can also be reduced by tingeing each color with a bit of the other. The colors will appear slightly muted. This prac-tice is often a very effective and easy solution.

Palette work does not only consist of reducing natural contrasts in a scene with vegetation. It also involves not creating undesired contrasts by the incorrect application of mixtures. Very dark mixtures of directly complementary colors must be avoided, because they harden a work.

*Here is a landscape with abundant color.*

*Vicenç Ballestar heightened the natural contrasts in watercolor, harmonizing forms and color masses.*

# HARMONIZATION

The purpose of harmonizing colors that appear in a painting is to gain a pleasing view of the whole. The range of possibilities is very wide. Harmony can be achieved by the inclusion of subtle contrasts, but a balance must always be sought.

## Unpleasant Contrasts

Some natural contrasts, especially in the plant world, can be annoying. This is a very personal decision.

A very strong contrast that can be forceful to view is the result of juxtaposing reds and greens in their maximum intensities. However, such a contrast is not always considered disagreeable. Some cultures base their pictorial production precisely on this natural contrast. The same is true of the contrasts between yellow and blue or red and blue.

Therefore, there is no universal culture of color. The different ethnic and cultural tendencies existing throughout the world must be respected.

These fruit trees by Gustav Klimt show a palette of delicate, cool pastel colors with just the slightest contrast created through small touches of warm colors, many of these light in tone.

In harmonization studies, some artists painted the same subject or a similar one using different palettes, as is the case of Gustav Klimt. Rosebushes Under the Trees shows the delicate harmony that can be achieved with a range of warm-neutral colors.

## How to Harmonize

Considering the cultural differences, artists tend to create individual variations in their choice of color. The artist can opt for several solutions. He can choose to create a complete harmony, using a harmonic range of colors. He can vary his color scheme by adding contrasting color to the dominant range. A warm color range is certain to contrast with a cool one. A range of neutral warm colors contrasts with a pure warm range. The same is true of cool colors, neutral vs. pure. A neutral warm range contrasts with a neutral cool range. In short, any variation can be interesting, depending on the personal selections made.

## How to Create Ranges

Palette work for creating a specific harmonic range requires few colors in the mixtures. The remaining colors are not used or are used in small quantities.

Thus, to create a warm harmonic range, mixtures will involve warm colors, either pure or neutral. Cool colors will only be used in small quantities, above all to darken and add tones to warm mixtures.

Similarly, a cool harmonic range will use only cool colors in mixtures. These are blues, greens, and grays. The re-

### Creation of Contrasts

Contrast results when touches of cool colors are interspersed within a work with a generally warm harmonic range. If the cool colors are tinged with a bit of a warm color, the result will be a fully harmonic work. If pure cool colors are used, there is no attempt at harmonization, but rather hard contrast is sought.

The contrasts in a neutral harmonic range are muted, the result of subtle shades. The general contrast between warm neutral and cool neutral colors can be used to capture, respectively, the colors of elements that are in the light, generally warmer, and those in the shadow, which are cooler.

maining colors of the palette, such as yellows or reds, are used to add different tones or hues, although with the latter one must proceed with great caution in mixing complementary colors.

The complete range of neutral colors is undoubtedly the most harmonic of all. All of the colors in it are delicate and subdued and generally include a great deal of white, which gives them pastel tones.

---

**MORE ON THIS SUBJECT**

- Color theory **p. 24**
- The palette **p. 26**
- Natural contrast **p. 88**
- Interpretation **p. 92**

---

*Giovanni Segantini (1858–1899) uses a splendid palette in his* Spring Pastures. *His mastery of warm greens is one of the secrets of the charm of this harmonious work.*

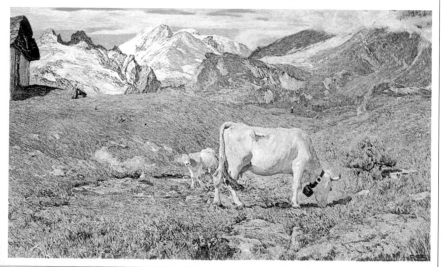

# INTERPRETATION

The process of interpretation is not limited to color. Shapes are also interpreted. This arises from the need to create a synthesis or a special rhythm. There can be varying degrees of abstraction in the general color structure or in the creation of shapes.

## The Creative Process

The creative process is undoubtedly one of the most personal processes in existence. The artist establishes an infinity of relations that no one else can produce. Interpretation involves an infinity of juxtaposed or superimposed color strokes. It is the relation that the artist establishes among them, at times with a specific objective or message. At other times it is a simple exercise in color and texture.

## The Evolution of Interpretation

Giuseppe Archimboldo and Hieronymous Bosch are important links in the path toward fantastic images, using realistic representation. The texture of these representations is acade-

*Odilon Redon used a decorative plant element to frame his* Portrait of Miss Violet Haymann. *This is the artist's prerogative.*

mic and involves fine layers of paint and the luminosity of transparencies.

Impressionists have added texture to their works through impasto and have contributed studies of optical mixtures. In this manner of painting, forms become blurry when seen up close.

However, the path toward abstraction is not limited to color and texture, and continues with the Post-Impressionists, Expressionists, and Cubists until purely abstract art is reached.

After all of these movements, contemporary artists have gained absolute freedom in their use of color and shape.

*Giuseppe Archimboldo.* Winter. *1563. Note the effect produced by elements of vegetation organized to create a human-like figure.*

**MORE ON THIS SUBJECT**

- Color theory **p. 24**
- The palette **p. 26**
- Natural contrast **p. 88**

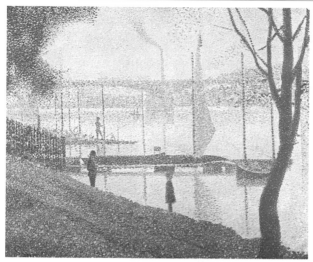

*Georges Seurat.* Bridge at Courbevoie, *1886. The style used by the artist involves a personal interpretation of the landscape that was his model.*

## Educating Our Sensibilities

Despite the absolute freedom that contemporary artists have today, it is important to keep in mind the values of harmonization—whether to enhance accord, or to create contrast, aggression, and provocation.

We learn by analyzing works by the great masters. Then, when creating our own works, we can draw on their studies of nature.

## Simple Ranges

A simple harmonic range is created on the basis of one color (the dominant one in the work), and three others of a tone opposite to the first, one of which should be its direct complement.

The use of simple ranges allows for greater contrast. Vegetation with a great deal of autumn colors can be developed in a simple harmonic range: tertiary violet-blue, primary blue, tertiary blue-green, and tertiary orange (the complementary color of tertiary violet-blue).

To avoid gray or muddy colors, the directly or indirectly complementary color pairs must be combined, always mixing them in unequal amounts.

### Subjective Harmony

Even in a contrastive work, harmony can exist, since a contrast can be integrated into the whole of the work. The general standard is based on palette work, using the most harmonic possibilities of complete cool, warm, or neutral ranges. The possibilities are infinite.

*Contrast can preside not only over the treatment of color, but also that of shapes, as in this path filled with synthesis and contrasts.*

# MIXED MEDIA

Using two or more media in representations of vegetation is not an uncommon practice. In addition to showing the inclination of each artist, with different interpretations and styles, this practice allows contrasts to be dramatized or facilitates chromatic or textural effects.

## Special Effects

Each medium has its characteristic features. Using mixed media with different techniques allows both media to be combined in a single work. Very interesting contrasts can be created.

This is the case with markers and watercolors, where the curviness and intensity of the lines made in marker are heightened by the brushwork of the watercolors, whose transparency and luminosity become even more apparent.

Pastels, a dry medium, combined with wax crayons, a greasy medium, create very special textural effects. Wax crayons, a greasy medium based on wax, and oil paints, another greasy medium but based on oil, can also be combined in the same work. The addition of wax crayon work in an oil painting allows matte effects that contrast with the

glossy finish typical of oils.

Watercolor and gouache are two water-based media that are highly compatible. It is quite common to use white gouache when painting a watercolor in order to recover an area of white or to create other contrasts. It is also quite common to alternate gouache and watercolor in a work to depict textural contrasts.

*In watercolor, the necessary washes are applied to add color to the entire landscape.*

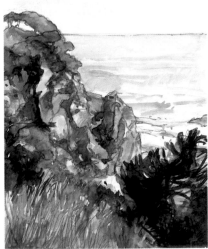

*This drawing, done in black marker, serves as a guide for this work in mixed media.*

*Once the watercolor has dried, markers can be used over it to obtain enriching textures.*

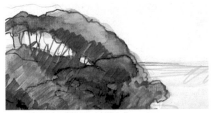

Acrylic is often used as the underpaint for a work to be finished in oil. This is a way of avoiding the slow drying process of oil in the initial blocking in. However, they can also be used alternately to add contrast in the final work.

**MORE ON THIS SUBJECT**

• The objective and analysis **p. 66**

## More Creative Possibilities

There is a wide range of fine art products for obtaining textures of great relief and thickness quickly and easily. This is the case of *acrylic modeling paste,* which can be applied on any type of support with a surface with the appropriate adherence capacity. This paste has an acrylic base and marble dust content, poly-

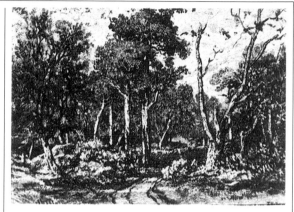

*This landscape by Corot was done in India ink and tempera.*

merizes quickly, is compatible with any acrylic product, and allows for as much impasto as desired in layer upon layer.

Works in thick acrylic, typical of avant-garde art, can be complemented or alternated with academic transparency techniques in oil.

Another tendency very much in vogue proposes flat textures and colors. Research in color ranges for acrylic has lead to fabulous colors that are difficult to find in the real world. These colors, when incorporated in any work, offer true impacts.

### The Researcher

Today, practically everything that there is to discover in the world of fine arts has already been discovered. However, artists can still represent their unique interpretation of colors and forms, combining different techniques and media. Their success lies in the way they are combined. The originality of the work is without a doubt the foundation of contemporary art.

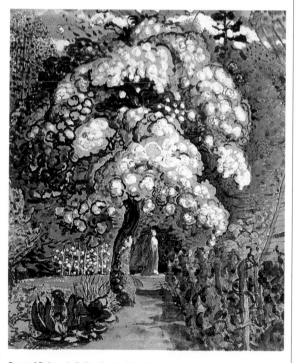

*Samuel Palmer's* A Garden in Shoreham *uses watercolor and gouache.*

Original title of the book in Spanish: *Vegetación*
© 2000 Parramón Ediciones, S.A.
Published by Parramón Ediciones, S.A., Barcelona, Spain.
Author: Parramón's Editorial Team
Illustration Archives: Carmen Ramos

*All inquiries should be addressed to:*
Barron's Educational Series, Inc.
250 Wireless Boulevard
Hauppauge, New York 11788
**http://www.barronseduc.com**

International Standard Book No. 0-7641-5353-6

*Library of Congress Catalog Card No. 2001086499*

Printed in Spain

9 8 7 6 5 4 3 2 1

Note: The titles that appear at the top of the
odd-numbered pages correspond to:

The previous chapter
**The current chapter**
The following chapter